Math +Art fun

bright sky press
HOUSTON, TEXAS

2365 Rice Boulevard, Suite 202,
Houston, Texas 77005

10 9 8 7 6 5 4 3 2 1

ISBN 978-1-933979-89-2
Library of Congress Cataloging-in-Publication Data on file with publisher.
Printed in China through Asia Pacific Offset.
Creative Direction, Ellen Cregan; Design, Marla Garcia; Editorial Direction, Lucy Chambers

put on
Your
MATH
GOGGLES!

Math
+ Art
fun

Activities for Discovering
Mathematical Magic
in Modern Art

Robin A. Ward, Ph.D.

bright sky press
HOUSTON, TEXAS

..

TO MY TWO BUDDING ARTISTS, MY CHERUBS, SIENNA AND SOPHIA. YOU COLOR AND SHAPE MY LIFE WITH YOUR LOVE AND SMILES.

BIG HUGS TO THE CHILDREN IN CAMP GEM AS WELL AS TO THOSE STUDENTS ENROLLED IN THE EARLY CHILDHOOD PROGRAMS AT WEST UNIVERSITY METHODIST PRESCHOOL IN HOUSTON, TEXAS, AND AT ALL SAINTS' EPISCOPAL SCHOOL IN FORT WORTH, TEXAS. HAD YOU NOT BEEN WILLING TO DON YOUR "MATH GOGGLES," THIS BOOK WOULD STILL BE A DREAM.

AND THANK YOU TO MY COLLEAGUES AT THE RICE UNIVERSITY SCHOOL MATHEMATICS PROJECT FOR YOUR STEADFAST AND ENTHUSIASTIC SUPPORT…AND ENDLESS HUMOR.

..

> **" Mathematical genius and artistic genius touch one another. "**
>
> – GOSTA MITTAG-LEFFLER,
> 20TH CENTURY SWISS MATHEMATICIAN
>
> **" Painting is a science and all sciences are based on mathematics "**
>
> – LEONARDO DA VINCI,
> ARTIST AND MATHEMATICIAN EXTRAORDINAIRE

NOTE: Both of these men *always* donned their math goggles.

table of contents

MAthemAticſ iN Art?

● ● ● ● ● ● ● ● ● ● ● ● ● ● ● ● ● ● ● ●

paint, gluesticks, and pastels in the mathematics class-room? Absolutely!

Even if you don't know a lot about mathematics, the connections between mathematics and the visual arts are obvious; for example, one can't help but notice Matisse's abundant use of *patterns* in many of his works or Piet Mondrian's trademark intersecting horizontal and vertical lines in his abstract works. And then there are Paul Klee and Wassily Kandinsky, two talented artists who adored painting *shapes* and even more shapes in their colorful abstract works. And how about Georgia O'Keeffe's grand use of *scale* in her large-than-life size paintings of flowers? Patterns, lines, shapes, scale—that's mathematics!

For me, I began donning my math goggles at a young age, as I could not get enough of solving puzzles—all kinds of puzzles—whether they be number puzzles, word puzzles, or jigsaw puzzles. I still remember being about 12 years old or so, and running to the mailbox at the start of each month, hoping I would find the latest edition of *Games* magazines inside the hollow, metal container. I delighted in their vast array of logic and number puzzles, along with their tantalizing eyeball benders and double cross puzzles. And then there is my love of cryptograms, which I do only *without* a pen, as I love the challenge of attempting to mentally store the one-to-one correspondence between and among the letters of the alphabet and the letters of the quote to be deciphered. In retrospect, I guess it makes sense that I chose mathematics as my major in college and as the focus of my doctoral studies since, for me, mathematics is thrilling, magical, precise, and abundant. With your math goggles on, you can see mathematics everywhere. Let me explain...

I have been working as a Professor of Mathematics Education for fourteen years now and, every time I engage a group of teachers (or future teachers), I always encourage these educators to wear their "math goggles" at all times. Now what do I mean by this? What

I am trying to awake in these educators is the importance of looking at their world through the lens of mathematics and to recognize and celebrate how mathematics abounds in our world—and to convey this to their students via engaging, hands on, exploratory, and authentic activities. For me, an educator is not only responsible for teaching mathematics content (and teaching it very well!), but he/she is also responsible for instilling in students a love and passion for the magic and multitude of mathematics in our world. And the visual arts serves as a perfect lens to see the beauty and abundance of mathematics!

Thus, the birth of this book. This book, which is as much about art as it is math, is a collection of integrated, hands-on activities that allows young learners to discover the world of the visual arts—the painters, their techniques, the many art movements, the elements of art, the various mediums used—while experiencing how mathematics permeates this realm. With your child, discover the beauty and symmetry in Maria Sibylla Merian's butterflies and then create your own patterned, winged creature. Or, use Andy Warhol's art as an exploration into the similarities and differences between and among cones, cylinders, and spheres. Or, encourage your child to create a pointillist work and then estimate the number of colored dots they see. These are just some of the exciting activities in this book that will help your child bridge the worlds of mathematics and the visual arts.

Given that the arts continue to get squeezed from the elementary school curriculum, what could be better than to seize the opportunity to recapture this body of work and to share the magic, color, and wonder of the visual arts with children and young learners while discovering, discussing, and applying mathematical concepts? So, come, put on your math goggles (they really are comfortable!) and experience mathematics in a whole new light by viewing it through the lens of visual arts! Discover how colorful, creative, and magical not only art can be, but how mathematics can be! By engaging in and exploring these mathematically-based, visual arts activities with your child, hopefully you will never have to answer the age-old question (that every mathematics teacher eventually hears), "When am I ever going to use this?"

before you put on your math goggles...(And how to gain the most from this book!)

• •

At the start of each activity, you will first find a brief biography about the artist whose work serves as the focal point to the activity. You will also discover fascinating facts about the artist as well as famous quotes attributed to the artist. Share all of this information with your child, as one of the goals of this book is to broaden the artistic horizons of children!

Before you proceed any further, take a moment, no, in fact, take *several,* and enjoy the artistic masterpieces that accompanying each activity. Create a dialogue with your child regarding what he/she likes about the artwork, what he/she sees in the artwork, how the title relates to the artwork, whether he/she sees anything mathematical about the work, etc. This book is as much about developing an appreciation for and understanding art and artists' techniques as it is seeing (ogling!), learning about, discovering, experiencing, appreciating, and understanding mathematics. Consider using outside resources (internet, library, encyclopedia, etc.) to ogle the other masterpieces that I suggest. This will provide both you and your child with a richer and more in-depth visual understanding of each artist's body of works.

Next you will see a list of the art and mathematics concepts/skills that will be explored while you and your child engage in the activity. You can certainly mention these concepts/skills to your child or, simply use them as a frame of reference for yourself as you proceed. (Note: In case you are looking to teach or reinforce a *particular* mathematics concept/skill with your child, look at the section in this book entitled, *Mathematical Overview of Activities,* a matrix which displays the specific mathematical concepts addressed within each art activity.)

Get ready and gather those materials! For those parents or

educators who prefer that their cherubs not become blanketed head-to-toe in glue and paint, I have made certain that the materials used in these activities are nothing that a little soap and water cannot remove! And, more importantly, you do not need high-end art supplies, like easels, oil paints, canvasses, etc. If you have construction paper, crayons, scissors and glue, you are *more* than ready to begin. For those teachers using this book, who may be limited in their abilities to set-up and clean-up due to time constraints, the vast majority of these activities can be seamlessly integrated into any classroom period and, further, will not require additional funds to secure supplementary materials or supplies.

Next, let the fun begin! As you follow my narrative outlining how to create your very own masterpiece in the spirit of the artist, enjoy every step of the process and even consider making your own masterpiece along side your child. You might be pleasantly surprised at how much you will learn about art, while having fun with your child!

Now, put on your math goggles and let the fun continue! In this section, the mathematics embedded in the art comes to life for you and your child to see, discuss, explore, and experience. In this section, I have articulated ideas that prompt you and your child to ogle the mathematics in your masterpieces, and I present potential mathematical questions to explore with your child. Additionally, I offer ways to create and sustain a rich mathematical dialogue with your child and, I further detail additional mathematical explorations appropriate for *younger children* (tailored for children ages 4-6 years), and those for *older children* (tailored for children ages 7-10).

At the end of each activity, I have included an annotated list of books; that is, I've included the titles and authors, along with a brief description, of related children's literature. Reading one (or more!) of these books to your child would be a wonderful way to begin or end any of these activities. In this list of book titles, I have included picture books, story books, sticker books, coloring books, biographies, as well as other pieces of non-fiction. Some of the books address art, while some address mathematical ideas and concepts. Although all of these books are available at popular booksellers and online, do check your local library first!

Following this, I have listed some nifty websites where you might

obtain more information about each artist and his/her works, as well as links that relate to mathematical concepts central to the activity. While I have selected only those websites that are child-appropriate, do make sure you view the website first to insure that the content has not changed. Once you approve of the website's content, *then* allow your child to continue exploring art while keeping his/her math goggles in place!

At the very end of my book, I have included an art glossary where you can learn more about various art periods, genres, and techniques. My book ends with a long list of *even more* titles and authors of children's literature, as well as *even more* art websites that you should consider ogling and sharing with your child.

So, get ready and put on your math goggles and enjoy every moment of this book—as you begin viewing mathematics through the lens of the visual arts.

the seven elements of art

If you were to build an ice cream sundae, what would you need? A dish, for starters and, most certainly, ice cream! But wouldn't it be nice to also have available sprinkles, nuts, hot fudge sauce, some whip cream, and a cherry for the top?

Well, if you want to build or create art, there are several ingredients you need, namely: line, shape, form, space, color, value, and texture. We call these the *elements of art* and they are the building blocks of art. What is fascinating about these seven elements of art is how mathematical they all are! Strap on your math goggles and find out how!

Let's start with the element of art called *line*. In mathematics textbooks, lines are generally those black, straight segments that form shapes. Or you might think of a line being continuous in both directions, like a number line. In art, lines can be thick or thin or even horizontal, vertical, diagonal, dashed, dotted, zig-zaggedty, curved, curly or swirly.

Shapes, those two-dimensional figures like rectangles, circles, squares, etc., are obviously mathematical. In fact, geometry is a branch of mathematics, which is the study of shapes. In mathematics, lines (well, more precisely, line segments) are used to create shapes. In art, when a line creates the boundary or outline of a shape, the result is the creation of what artists call a positive image (the region that is outlined) and a negative image (the remaining background, or what is outside the boundary).

While *shape* refers to two-dimensional figures, *form,* in art, refers to three-

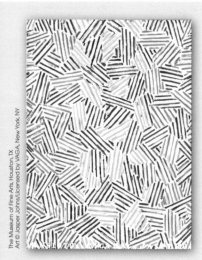

↗ Ogle all those colorful *lines* in Jasper Johns' *Cicada* (1979)!

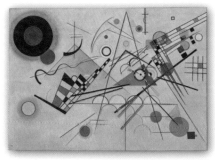

Solomon R. Guggenheim Museum, NY

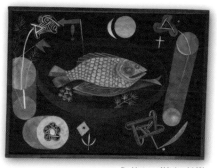

The Museum of Modern Art, NY

↗ Can you count and name the various **shapes** dancing about in Wassily Kandinsky's *Composition 8* (1923)?

↗ Ogle the **forms** (and lines and shapes!) in Paul Klee's *Around the Fish* (1926).

dimensional figures—like cones, cylinders, spheres, pyramids, and prisms. These forms sure sound mathematical to me!

In art, *space* is described as the area or distance around things, whether it be above or below, in front or behind, or between or within. When objects overlap, the ones in the front appear closer than the ones farther behind. Similarly, when objects in a piece of artwork vary in size, the larger ones seem closer, while the smaller objects appear farther away. When objects appear at different distances, this gives the viewer a sense of perspective; that is, the viewer's impression of each object's relative position and size. Wow...look at all the words that I used to describe *space:* area, distance, larger, smaller, perspective. These are all mathematical concepts or terms!

Now what about *color?* Most certainly, you can't think about art without thinking about color! Color is what we see when light strikes an object and reflects back to our eyes. But how can *color* be mathematical, you ask? Well, how do you make orange? If you use one part red and one part yellow,

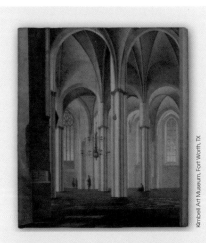

Kimbell Art Museum, Fort Worth, TX

↗ Ogle the three-dimensional **space** created by Pieter Jansz Saenredam in his *Interior of the Buurkerk, Utrecht* (1644), and let your eyes wander through the successive arched cathedral ceilings.

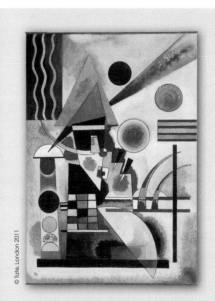

© Tate, London 2011

↗ Can you see and feel the music and emotions Wassily Kandinsky associated with **color** in his work entitled, *Swinging* (1925)? Oh, and look at all of those lines and shapes! Count them!

you make orange. In other words, you create the color orange by combining equal amounts of color, say, for example, one-half red and one-half yellow. Fractions!!! Ah, there's the math!

Now what is this thing called, *value*? In art, *value* is the measure (oh, there's a math word!) of how light or how dark a color is. For example, if you wanted to make a bright reddish orange, you might mix three parts red with one part yellow. On the contrary, if you wanted a softer, lighter orange, you might do just the opposite and mix one part red with three parts yellow. Ah...there's the mathematics! Knowing about ratios and proportions (that is, the amount of part or parts relative to the whole) can help one understand what *value* is.

Finally, when I think of *texture,* I reminisce about my childhood, when I would visit my grandmother at her tiny house situated in the outskirts of Philadelphia. Nearly every room was adorned with flocked wallpaper—you know, the fuzzy-to-the-touch wallpaper. I still recall the floral, lined, and paisley patterns on the textured walls. Ah, patterns! There's the math!!

As you and your child engage in the twenty-two (Ah, 22 is a mathematical palindrome!) activities in this book, keep these elements of art alive in your imagination as you dream, visualize, discover, interpret, and create art. Also, talk about what you both like (and maybe even what you don't like!) about each work of art. Does the work of art appeal to you? What do you think the artist was thinking and feeling as he/she created his/her masterpiece? Does the title make sense and help (or hinder!) you in seeing what might be the artist's meaning in his/her works? Developing an appreciation for art, the different techniques, the different mediums that can be used, the various genres, and how beauty does lie in the eye of

the beholder, is critical—and another goal of this book.

Oh, and as you view and enjoy each piece of art in this book, remember to wear your math goggles at all times! Look for the mathematics!

↘ Josef Albers dabbled in **value** (and shape!), painting some squares lighter shades or darker shades than others, like in his *Homage to the Square: "Gentle Hour"* (1962).

↘ Can you ogle and almost feel the **texture** of the frozen fields in the heavy paintbrush strokes of Vincent van Gogh's *Landscape with Snow* (1888)? The lines of varying value emote the feeling of frozen fields.

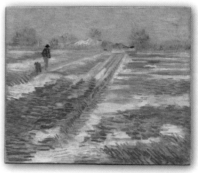

Solomon R. Guggenheim Museum, NY

Collection of Walker Art Center, Minneapolis, MN

Mathematical
overview of
Activities

• • • • • • • • • • • • • • • • • • • •

Are you looking to explore a particular mathematical concept with your child? Use this chart as a guide to identifying the overarching mathematical concepts/skills that appear in each activity.

MATH CONCEPTS CHART

NAME OF ACTIVITY	NUMBER AND OPERATIONS	PATTERNS AND ALGEBRA	GEOMETRY	MEASUREMENT	PROBABILITY AND STATISTICS
Square Dancing with Josef Albers			X	X	
Taking a Chance on Hans Arp			X		X
Alexander Calder's Marvelous Mobiles	X	X		X	
What Is Salvador Dali Dreaming About?				X	
Looking Down and Around with Richard Diebenkorn			X	X	
Clementine Hunter's Folk Art 1, 2, 3	X				
Jasper Johns' Fancy Flags	X	X			
Jasper Johns Shades in the States	X		X		
Wassily Kandinsky's Serene Circles			X	X	
All Lined Up with Paul Klee	X	X	X		X
Paul Klee's Cityscape of Stacks and Shapes	X		X		
Roy Lichtenstein's Bountiful Benday Dots	X				
Patterns Run Amok with Henri Matisse!		X			
Henri Matisse's Sneaky Snail Spiral		X	X		
Maria Sibylla Merian's Beautiful Bugs and Butterflies		X	X		
Joan Miró Awakes to Shapes!			X		
Edvard Munch Has Pier Perspective!			X	X	
Georgia O'Keeffe's Grand Sense of Scent and Scale	X		X	X	
Pablo Picasso's Plentiful Prisms			X		
Jackson Pollock Makes a Multi-Colored Mess!	X		X		
Georges Seurat's Countless Dots	X			X	
Dinner and Dessert with Andy Warhol			X		

square dancing with josef albers

J OSEF ALBERS (1886-1976) was a German-born American abstract artist who was also a very accomplished educator, furniture designer, photographer, printmaker, and poet. He was a student of, and then taught at the Bauhaus (a prestigious German art/design school) and was on the faculty at Black Mountain College in North Carolina as well as at Yale University. Albers' most famous works are the hundreds of paintings in his *Homage to the Square* series, which he painted between 1950 and 1976. When creating each work, he'd begin by priming the rough side of Masonite (which is a type of wood fiberboard) with six coats of white paint. Most often, he would begin painting the center square and move outward, always under a careful arrangement of lighting, which allowed him to

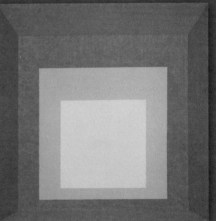

Solomon R. Guggenheim Museum, NY

↗ Josef Albers, *Homage to the Square: Apparition* (1959). How many squares do you see?

capture the mood, color, and value of color emanating from each work. Albers is also known for his innovative 1963 publication, *The Interaction of Color,* which articulates his unique ideas of color experimentation.

fascinating facts

- Quite often, Albers would record on the back of his works the paints, the spatial proportions, and the mathematical schemes he used, as Albers wanted his viewers to understand his approach to art.
- Albers' paintings form the foundation of Op art.

FAMOUS QUOTES

"I prefer to see with closed eyes."

"If one says "Red"—the name of color—and there are fifty people listening, it can be expected that there will be fifty reds in their minds. And one can be sure that all these reds will be very different."

MASTERPIECES TO OGLE

Homage to the Square series (1950-76)
Stacking Tables (1926)
Fruitbowl (1924)

ART CONCEPTS/SKILLS: abstract art, op art, line, shape, color, value

MATH CONCEPTS/SKILLS: shape, polygon, squares, magic squares

WHAT YOU'LL NEED

- 8.5" X 11" cardstock (or watercolor paper) cut to a square size (say, 8" X 8")
- watercolors (or crayons or markers)
- ruler
- toothpicks

LET'S HAVE FUN!

View, enjoy, and discuss some of Albers works in the *Homage to the Square* series. They all feature squares, but the squares are different in color and vary in value. Which work do you like best? Why? What

other elements of art do you see in his works?

Can you make a guess as to why Albers chose to paint squares? During an interview in 1968 for the Smithsonian Institution, Archives of American Art, Albers stated that he preferred squares to circles because circles "fool" him. Huh? Albers said that you couldn't tell when a circle is rolling or moving, because its outer curve never changes in appearance. However a square to him is more "honest," as he called it, because you can tell on which side it is sitting, usually the bottom, horizontal side. Albers also had a preference for squares because, in his opinion, you do not really see squares in nature, as compared to other shapes; thus he had "sympathy" for this shape, which was what he called "a human invention."

Create your own Albers-like masterpiece! Find two square objects of varying size (e.g., lid, napkin, book, etc.) and trace them onto a piece of square paper. (You might even trace the squares onto a piece of wood or fiberboard—which is what Albers would use.) Trace the smallest square object first. Place the larger sized square on top of the sketch of the smaller square, centering it. Trace this square. Using watercolors, crayons, or markers, color your three-square masterpiece, with a focus on value and color.

View your work and title it. What other elements of art do you see in your masterpiece?

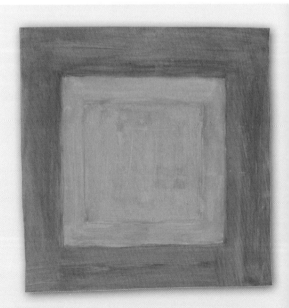

↗ *Three Squares;* Sophia (age 7) chose the colors of her favorite fruits—apples, oranges, and lemons—and kept adding water to her watercolors, until she obtained each color's most pleasing value.

put on Your Math goggle/!

Mathematically speaking, a square is a quadrilateral (which is a fancy word for a four-sided figure) with four right angles (meaning the angles measure 90 degrees) and four congruent sides (meaning all sides have the same length).

With younger children: Squares abound in our world, so encourage your child to look for squares around him/her, as he/she will see many real life examples (e.g., windows, faces on a die, computer screens, etc.). Ask your child to describe the features of a square (e.g., a square has four sides; all sides have the same length, etc.).

Using toothpicks, encourage your child to build squares of different sizes. Remember, what makes a square a square is the fact that all four of its sides are of equal length and all four of its angles (what kids call "corners") measure 90 degrees (so the angles look like the letter 'L.'). So, place those toothpicks carefully!

With older children: Just as with younger children, encourage older children to look for squares in their world. Challenge them to use a ruler to practice drawing and measuring squares of different sizes.

If your child has begun learning about area, ask him/her to measure each square in his/her Albers-like masterpiece and to compute each square's area. Ask your child the following: If the largest square in his/her Albers-like work is double the size of the smallest square (that is, its edge measures two times bigger), what can you say about the area of the larger square? Is it also double in value? Actually, it's not! The area of the larger square is not two, but four times bigger. Why? Suppose the smallest square measures 3 inches on each edge, so its area is side times side, or 9 inches squared. If the larger square has an edge that is double the smaller square's edge, then each of its edges measure 6 inches each, which would yield an area of 6 times 6 or 36 inches squared. Thus, its area is four times bigger (because 36 is four times bigger than 9).

Introduce your child to a magic square puzzle! A magic square is a super fun mathematical puzzle, which really makes

kids think! A magic square is in the shape of a square grid (e.g., a 3 X 3, 4 X 4, 5 X 5 grid, etc.). To solve a magic square, the sum of the entries in each row and in each column must add to the same value, and the two diagonals sum to the same "magic" number. To complete a 3 X 3 magic square, you will use the numbers 1-9 once and only once. In the case of a 4 X 4 magic square, you will use the numbers 1-16 once and only once. The inventor, scientist, and statesman, Benjamin Franklin was known to love designing and solving magic squares. See if you do, too!

BOOKS TO OGLE

An Eye for Color: The Story of Josef Albers by Natasha Wing
 Enjoy a colorful biography of the artist, Josef Albers.
What Is Square? by Rebecca Kai Dotlich
 Rhyming verse accompanies photos of everyday objects that are square.
Squares (Welcome Books' City Shapes Series) by Jennifer S. Burke
 See real life examples of squares in a city.
The Legend of Spookley the Square Pumpkin by Joe Troiano
 Being square has its benefits!

WEBSITES TO OGLE (PLEASE VIEW BEFORE SHOWING TO YOUR CHILD IN CASE CONTENT HAS CHANGED.)

The Josef & Anni Albers Foundation
 http://www.albersfoundation.org/
The Josef & Anni Albers Foundation–Josef Albers Gallery
 http://www.albersfoundation.org/Albers.php?inc=Galleries&i=J_1
Museum of Modern Art (MoMA)–The Collection of Josef Albers
 http://www.moma.org/collection/browse_results.php?criteria=O%3AAD%3AE%3A97&page_number=1&template_id=6&sort_order=1
Magic Squares
 http://mathforum.org/alejandre/magic.square.html
Magic Squares Worksheets
 http://www.dr-mikes-math-games-for-kids.com/magic-square-worksheets.html

ᴛᴀᴋɪɴɢ ᴀ ᴄʜᴀɴᴄᴇ ᴏɴ ʜᴀɴʃ ᴀʀᴘ

HANS (JEAN) ARP (1886-1966) was a German-French sculptor, painter, and poet who was the son of a German father and French Alsatian mother. Arp was a very versatile artist, who was a pioneer of abstract art, a founding member of the Dada movement in Zürich,

and an active participant in the Surrealism movement. Arp, who referred to his sculptures as "concretions," created a monumental (that means really big) wood and metal relief for Harvard University, a mural relief for the UNESCO Building in Paris, and even won the international prize for sculpture in 1954 at the Venice Biennale. Some of his most distinctive sculptural works resembled nature, such as hills, clouds, animals, and plants. Arp became famous for his "chance collages," in which he would drop torn pieces of paper onto a larger sheet, and then paste each scrap into place wherever it happened to land. However, many art critics argued that Arp's chance collages were regular and uniform in appearance, and therefore not created by chance. What do you think?

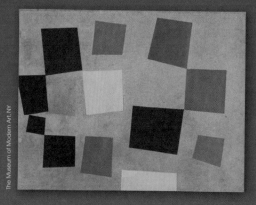

The Museum of Modern Art, NY

↗ Hans Arp, *Untitled (Squares Arranged according to the Laws of Chance)* (1917). How many squares do you see? Was this collage made by chance?

fascinating facts

- When speaking in German, Arp referred to himself as "Hans," but when speaking in French, he referred to himself as "Jean."
- Throughout the 1930s and until the end of his life, Arp wrote and published essays and poetry.

FAMOUS QUOTES

"Art is a fruit that grows in man, like a fruit on a plant, or a child in its mother's womb."

"The law of chance can be experienced only in a total surrender to the unconscious."

MASTERPIECES TO OGLE

Untitled (Collage with Squares Arranged According to the Laws of Chance) (1916-17)
Objects Arranged According to the Law of Chance (1930)
Birds in an Aquarium (1920)
Leaves and Navels (1929)

ART CONCEPTS/SKILLS: dada, shape, collage

MATH CONCEPTS/SKILLS: chance, probability, shapes

WHAT YOU'LL NEED

- 8.5" X 11" white card stock
- multi-colored squares (1.5" X 1.5" or 2" X 2") of tissue (see website below for precut, colored square tissues)
- gluestick

LET'S HAVE FUN!

View, enjoy, and discuss some of Hans Arp's works. Do you like his artwork and his sculptures? Do you see elements of nature in his sculptures?

Look carefully at Arp's chance collage entitled, *Untitled (Squares Arranged according to the Laws of Chance)*. Some art critics believe that the fallen squares of torn tissue seem orderly and thus, perhaps Arp did not leave their placement according to the laws of chance. What do you think? Do you think these torn tissues fell randomly and haphazardly, without any guidance or human interference? Do you think Arp was wearing his math goggles and thinking about chance and probability when he created his chance collages?

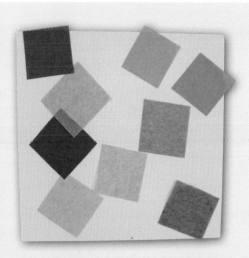

↗ *Rainbow Chance Collage;* Pierce (age 4) thought his dropped squares matched the colors of the rainbow.

Create your own chance collage by using a gluestick and spreading glue across a piece of white cardstock. Drop pieces of colored tissue, one at a time, onto the white cardstock, gently pressing each into place after it lands. View, title, and enjoy your chance collage. What elements of art do you see in your masterpiece?

put on Your Math goggles!

The idea of "chance" is the foundation of the study of probability, which is a measure of how likely it is that some event will occur. For example, you could say there is a 50% chance (or 1 chance out of 2) of flipping a coin and having it land on heads. Or, without using numbers, you might say that there is a *slight* chance of rain today. The probability of an event occurring ranges between the values of 0% (e.g., meaning something won't or can't happen, like the chance of pigs flying) to 100% (e.g., meaning something will definitely happen, like the chance of a blueberry being blue).

With younger children: Engage in simple discussions that incorporate probability terms. For example, ask your child: "Is it *likely* that it will snow today? What are the *chances* of you eating all of your vegetables tonight at dinner? What is *possible?* What is *impossible?* What is *unlikely?*" Help your child to understand the differences between and among these conversational (and mathematical!) terms.

Experiment with spinners (see websites below) or play games that allow your child to understand and gain practice with the concept of chance. For example, play, *What's in the Bag?* Place four blocks in a bag, three of one color and one of a different color. Ask your child to reach into the bag, pull out one block, notice its color, and place it back in the bag. In mathematics this is called *sampling with replacement.* Repeat three more times. Based on the results of your four draws, how many of each block do you think are in the bag? Repeat this experiment using various numbers and combinations of colored blocks.

With older children: As with younger children, engage your child in conversations that incorporate probability terms. Challenge them to think of something that is *probable* as compared to something that is *possible.* What event has a 0% chance of occurring? A 100% chance? A 50% chance? Less than a 50% chance? Name two events that are equally likely.

Using a deck of 52 cards, discuss the probability of drawing, say, a red card (26 out of 52, or 50%) or a black eight (2 out of 52, or 4%). Are your chances better of drawing a face card (12 out of 52, or 23%) or a spade (13 out of 52, or 25%)?

Also, have fun exploring probability using dice or spinners.

BOOKS TO OGLE

Cloudy with a Chance of Meatballs by Judi Barrett
 What are the chances of food falling from the sky? Find out what happens to the residents of Chewandswallow in this zany tale.
A Very Improbable Story by Edward Einhorn
 Introduce older children to the idea of probability by finding out what happens to a boy when he wakes up with a cat named

Odds sitting on his head.

Do You Wanna Bet? Your Chance to Find Out About Probability by Jean Cushman

Older children will enjoy easy-to-read explanations of what might be considered a complex concept.

Averages by Jane Srivastava

Discover simple explanations for the different types of average (mean, median, mode), how to compute them, and how they are used.

WEBSITES TO OGLE (PLEASE VIEW BEFORE SHOWING TO YOUR CHILD IN CASE CONTENT HAS CHANGED.)

Museum of Modern Art (MoMA) on Jean Arp (Hans Arp)

http://www.moma.org/explore/multimedia/audios/29/737

National Library of Virtual Manipulatives–Spinner Activities

http://nlvm.usu.edu/en/nav/frames_asid_316_g_1_t_4.html?from=category_g_1_t_4.html

http://nlvm.usu.edu/en/nav/frames_asid_186_g_2_t_5.html?open=activities&from=category_g_2_t_5.html

National Council of Teachers of Mathematics Illuminations: Adjustable Spinner

http://illuminations.nctm.org/ActivityDetail.aspx?ID=79

Mini Colored Tissue Squares

http://www.discountschoolsupply.com/Product/ProductDetail.aspx?product=22927&keyword=colored%20tissue%20squares&scategoryid=0

Alexander Calder's Marvelous Mobiles

ALEXANDER "SANDY" CALDER (1898-1976) was an American artist, painter, and sculptor, born in Pennsylvania, who began his career as an engineer. It was his engineering background that served as a catalyst for his later career as an artist and sculptor, as his knowledge of mechanics helped him balance his famous mobiles. Some of Calder's first sculptures were made of wire; in fact, Calder's *Cirque Calder,* begun in 1926, was a miniature circus fashioned from wire, string, rubber, cloth, and other materials, which was hugely popular in Paris. Many of these wire circus figures had moveable parts. In 1931, Calder created his first truly kinetic sculpture, which moved by a system of cranks and motors, and which was dubbed "mobile" by the artist Marcel Duchamp. Calder abandoned the mechanical aspects of these sculptures upon realizing they could undulate independently in air currents. Calder also created stationary objects called "stabiles", sculptures usually made of metal that looked different from varying viewing angles. Many of these stabiles now grace city squares throughout the world.

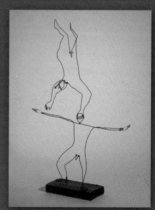

↗ Alexander Calder, *Two Acrobats* (1929). Look at those straight and curved lines! This looks like fun!

The Menil Collection, Houston

fascinating facts

- Calder's lifelong interest in the circus began when he took a job as an illustrator for the *National Police Gazette* and was assigned to cover the Ringling Brothers and Barnum & Bailey Circus.
- Calder's largest mobile, *Untitled,* hangs in the East Building of the National Gallery of Art and measures 76 feet long.

FAMOUS QUOTES

"I paint with shapes."

"To an engineer, good enough means perfect. With an artist, there's no such thing as perfect."

MASTERPIECES TO OGLE

Cirque Calder (1926-1931)
Jealous Husband (1940)
Boomerangs (1941)
Untitled (1976)
Spider (1940)
Portrait of the Artist as a Young Man (1947)
Flamingo (1973)

ART CONCEPTS/SKILLS: symmetry, balance, line, shape

MATH CONCEPTS/SKILLS: symmetry, multiplication, algebra, measurement

WHAT YOU'LL NEED

- wire
- string
- various objects to attach to your mobile
- Popsicle stick
- pennies
- pencil
- ruler

LET'S HAVE FUN!

View, enjoy, and discuss some of Alexander Calder's wire sculptures, mobiles (that hang with moving parts), standing mobiles (that balance on a base), and stabiles (that have no moving parts). Which sculpture is your favorite? Are you amazed at how so many of these works of art look unbalanced, yet do not tip over? What do you like most about Calder's *Cirque Calder?* What elements of art do you see in his creations?

Let's ogle Calder's *Two Acrobats.* Doesn't Calder marvelously capture the spirit of balance in this wire work? Which acrobat would you rather be?

Ogle Calder's *Untitled* (c. 1938). How is it that this mobile appears balanced, when there seems to be so much more hanging from the left-hand side of it? Was Calder also a magician, or did he know a lot about the mathematics of mobile making? Let's find out!

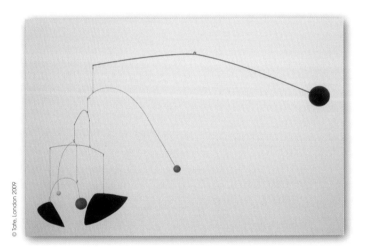

© Tate, London 2009

↗ Alexander Calder, *Untitled* (circa 1938). Mathematics makes this mobile balance!

Create your own mobile! Beginning with a length of wire, construct a mobile, but do not directly copy any work you may have seen, but rather use what you have seen as an inspiration to create your own sculpture. Use any combination of elements cut in any shape from paper, and/or found objects, wood, etc. Elements can

be attached directly to wire, or can be hung from wire by string, or any combination of techniques. When completed, paint your sculpture. Use a trial and error approach to attempt to make a mobile that balances. What is required to take a work that is not balancing properly, and make it balance?

View your mobile and then title it. What elements of art do you see in your Calder-like masterpiece?

put on your Math goggles!

How do Calder's seemingly unbalanced mobiles balance? It's all about mathematics! Calder drew upon his engineering background, in particular, his knowledge of Archimedes' *Law of Levers,* to make his mobiles balance. Kids might think of this as the Law of Seesaws, as a seesaw is an example of a simple lever.

Let's understand the Law of Levers by experimenting with levers and making a seesaw. Place a Popsicle stick perpendicularly on top of a pencil so that is balanced. By *perpendicular,* I mean for you to make a "cross" (or a small letter "t") using the Popsicle stick and pencil. Notice that when the Popsicle stick is centered on top of the pencil, the Popsicle stick is balanced. This balancing point is called the *fulcrum,* and it is located in the middle of the Popsicle stick.

Ask you child what will happen if he/she places a penny on the far left end of the Popsicle stick (the seesaw). Then, place a penny there, and test their hypothesis (their guess!). Just like on a seesaw, the left side goes down. Now, how could you balance the now unbalanced seesaw? Well, you might place another penny on the far right side of the Popsicle stick, similar to having a child sit on the other side of the seesaw, balancing out the child on the left-hand side. But, is there another way to make our seesaw (our lever) balance? If you keep the pencil perpendicular to the Popsicle stick, but slide the pencil slowly toward the penny, you will be able to balance your seesaw. Try it!

Having done this seesaw experiment, what is the secret to creating balance? Hold onto your math goggles and let's see why mathematics plays an important role in Calder's art.

Think back to when the Popsicle stick was balanced on top of the pencil. When the weight on the Popsicle stick was changed by adding a penny, our balanced lever became unbalanced. Thus, *weight* plays a role in maintaining balance. Then, in order to balance our unbalanced seesaw, we adjusted the distance of the penny to the midpoint (fulcrum) of the Popsicle stick. Thus, *distance* plays a role in creating balance.

The Greek mathematician, Archimedes, discovered what is known as the *Law of Levers,* which states that if you multiply the weight (W_L) and the distance (D_L) from the center point (fulcrum) on the left-hand side of a lever, the lever will balance if this value equals the same value as when you multiply the weight (W_R) and the distance (D_R) from the center point (fulcrum) on the right-hand side of the lever. Here is the Law of Levers written in symbols:

$$W_L \times D_L = W_R \times D_R$$

Had Calder not worked as an engineer early on in his career, we may not have had his marvelous mobiles to ogle today!

With younger children: Continue experimenting with balance and levers! Ask your child to place several pennies on one end of a Popsicle stick and only one penny on the other end. Challenge your child to shift the pencil (placed perpendicularly underneath the Popsicle stick) until he/she has located the balancing point, creating a balanced lever. Describe to your child how weight and the location of the balancing point (fulcrum) impact balance.

Go to a playground and experiment with weight and distance using a seesaw. Ask your child to sit on the farthest end of a seesaw. He/she will descend and touch the ground, while the other side of the seesaw rises. If your child changes his/her distance from the center point and moves towards the center of the seesaw, his/her side of the seesaw does not descend as

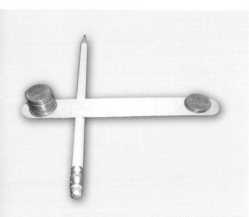

↗ Whoa! Even with all those pennies placed on one side of the Popsicle stick, Jimmie and Joseph (ages 10) were able to create a balanced lever...and had lots of laughs while doing so!

much, and the other end of the seesaw does not rise as much. This demonstrates how weight and distance affect balance!

With older children: Just as with younger children, experiment with balance by placing varying amounts of pennies on both sides of a Popsicle stick, in an attempt to create a balanced lever.

Gain practice with multiplication by testing the Law of Levers. Use a scale to determine the weights of the pennies placed on both sides of a Popsicle stick. Substitute into the Law of Levers the values for the weight of the pennies on both sides of the lever and their distances from the fulcrum (measure from the balancing point to the center of the stack of pennies). Do both sides of your equation equal one another?

Gain practice with algebra! Give your child three of the four variables used in the Law of Levers and see if they can figure out the fourth missing variable. For example, if the weight on the left-hand side of a lever equals four grams and the weights hang at a distance of 5 centimeters from the fulcrum, what must the distance from the fulcrum on the right-hand side be if the right-hand sides weight is 10 grams? (Answer: 2 centimeters, because 4 X 5 = 10 X 2).

BOOKS TO OGLE

Alexander Calder (The Life and Work of... Series) by Adam Schaefer
Learn about the life and work of Alexander Calder in this biography.

Alexander Calder (Sticker Art Shapes) by Sylvie Delpech and Caroline Leclerc

Create your own Calder-like mobiles and sculptures using colorful, reusable stickers.

The Man Who Walked Between the Towers by Mordicai Gerstein
You will be amazed to hear how a French trapeze artist maintained his balance and walked a mile high above New York City!

WEBSITES TO OGLE (PLEASE VIEW BEFORE SHOWING TO YOUR CHILD IN CASE CONTENT HAS CHANGED.)

Alexander Calder Foundation
http://www.calder.org/

National Gallery Of Art–The Collection–Alexander Calder
http://www.nga.gov/collection/calderinfo.shtm

Roland Collection of Films on Art–Alexander Calder's Circus
http://www.rolandcollection.com/films/?prm=a13-b103-c876-d2-e0

WHAT is SALVADOR DALi
dreaMINg ABOUT?

SALVADOR DALI (1904–1989) was a 20th century Spanish artist, born near the French border in Catalonia, Spain, best known for his surrealistic artwork, which meant that he painted from his dreams. In fact, Dali referred to his works as "hand painted dream photographs." Surrealists like Dali hoped that the strange-looking and unrelated objects in their works would cause people to think. One of Dali's most famous works, *The Persistence of Memory* (1931) features what might be described as "melting clocks." Some say he got this idea of time melting by watching a piece of cheese liquefy on a hot August day. Dali was also a sculptor, writer, photographer, filmmaker, and a designer of clothing, perfume bottles, theater sets, and magazine ads. With as busy as he was, it is a wonder he found time to sleep and therefore dream!

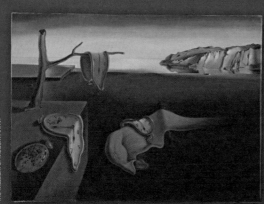

↖ Salvador Dali, *The Persistence of Memory* (1931). The human figure in the center of this painting is Dali himself.

fascinating facts

- Dali collaborated with filmmakers Roy Disney and Alfred Hitchcock.
- Dali was frequently expelled from school.

FAMOUS QUOTES

"People love mystery, and that is why they love my paintings."

"The only thing that the world will not have enough of is exaggeration."

"Every morning when I awake, the greatest of joys is mine: that of being Salvador Dalí."

MASTERPIECES TO OGLE

Clock Explosion (1931)
Les Elephants (1948)
Meditative Rose (1958)

ART CONCEPTS/SKILLS: surrealism

MATH CONCEPTS/SKILLS: telling time

WHAT YOU'LL NEED

- Silly Putty
- newspaper
- paper
- crayons or markers
- paper plate
- 1 large bobby pin
- 1 small bobby pin
- glue

LET'S HAVE FUN!

What do you see happening in Dali's *The Persistence of Memory?* What do you think Dali was trying to express as he painted? Why do you think the clocks look stretched out and limp, as if they are melting? Is time bending? And why are there ants scampering around on the stopwatch?

In this work, Dali, in the sprit of surrealism, tries to discredit reality and create confusion by showing hard objects (like a clock) becoming unexplainably limp and implying that metal (like on the stopwatch) is rotting flesh and therefore attracting ants. The only real image in this work of art is Dali's rendering of the golden cliffs (appearing at the top right) of Catalonia, Dali's home.

View and discuss other works of art by Dali. Do you like his vivid imagination and use of imagery in what he calls his "dream photographs"? What do you think he is trying to tell us through his works?

Press some Silly Putty onto a piece of newspaper. Lift it off and look! The ink from the newspaper now appears on the Silly Putty. Slowly stretch the Silly Putty and watch how the image becomes distorted and elongated, just like one of Dali's clocks!

Make a surrealistic painting in the spirit of Salvador Dali! Think about a dream you had recently or close your eyes and daydream. If a dream is not coming to mind, tap into your imagination! Sketch and then color the images and pictures that appear in your mind. Title your work and then share your masterpiece with a friend. Can your friend guess what the hidden meaning is behind your hand painted dream photograph? Does your masterpiece, with its dreamy images, appeal to your friend?

↗ *Dreaming of the Milky Way;* Serena (age 7) told me she was dreaming about angels in heaven and plants and planets as she created her Dali-inspired artwork.

put on your Math goggles!

Dali did not use math, per se, in the creation of his works, but he is famous for painting clocks. There's our math! So, let's talk about telling time! You can use a watch or clock on the wall to do this, or, even better, let's make your own clock. It's easy.

Take a paper plate and, using a pen or magic marker, write the numbers 1 through 12 on the outer edge of the plate, just as they appear on a clock.

Punch a tiny hole in the center of the paper plate. Insert one arm of both the large and small bobby pin through the hole. You now have a clock, where the arm of the large bobby pin is the minute hand and the arm of the small bobby pin serves as the hour hand.

Discuss with your child how there are 24 hours in a day, twelve hours of daylight and twelve hours of nighttime. For example, ask your child what happens at 7AM? You might be just waking up, but at 7 PM, you might be going to bed. Describe how the smaller (or shorter) hand of the clock, tells us the hour, while the larger (or longer) hand of the clock indicates how many minutes have elapsed. Have fun using your clock to tell time!

↗ My Dream Clock; Sam (age 5) enjoyed making and then telling time with his Dali-inspired clock. Do you think this clock would ever melt?

With younger children: Explain that when the "big hand" on the clock is pointing to the 12, we describe time as being "on the hour." Rotate the smaller hand of the clock to point to the 1, and then to the 2, and then to the 3, etc., while keeping the big hand on the 12, and demonstrate what one o'clock, two o'clock, and three o'clock, etc., look like. Challenge your child to show you, for example, 8 o'clock, 10 o'clock, midnight, etc.

With older children: Explain how to tell time on the half hour, quarter hour, etc., by describing that there are 60 minutes in one hour and moving the longer, minute hand around they clock and naming each minute and its corresponding time. For example, when the longer bobby pin (minute hand) points to the 3, this represents15 minutes past, or quarter past, the hour. When the minute hand points to the 6, it is half-past, or 30 minutes, past the hour, etc.

BOOKS TO OGLE

Salvador Dali (Getting to Know the World's Greatest Artists Series) by Mike Venezia
 Learn about tho life of Salvador Dali in this biography, complete with clever and humorous illustrations and images of the artist's work.

Dali and the Path of Dreams by Anna Obiols
 An adventure story, filled with surrealistic images, about a young boy named, "Little Salvi."

Salvador Dali Coloring Book by Prestel Publishing
 Color a variety of Dali's works—and put your own spin on each!

What's the Time, Mr. Wolf? by Annie Kubler
 Enjoy telling time, in the spirit of the like-named children's game, using a finger puppet. Digital and analog clocks are featured on each page.

It's About Time by Stuart Murphy
 Experience what happens in a young boy's twenty-four hour day. Includes activities on how to tell time.

How Do You Know What Time It Is? by Robert E. Wells
 For older children, a delightful, easy-to-read history of clocks and calendars.

WEBSITES TO OGLE (PLEASE VIEW BEFORE SHOWING TO YOUR CHILD IN CASE CONTENT HAS CHANGED.)

Salvador Dali
 http://www.factmonster.com/ce6/people/a0814523.html

The Dali Museum
 http://www.salvadordalimuseum.org/

Museum of Modern Art (MoMA)–Modern Kids: Salvador Dali
 http://www.moma.org/explore/multimedia/audios/1/10
Interactive - Telling Time
 http://www.apples4theteacher.com/java/telling-time/
National Library of Virtual Manipulatives–Interactive Telling Time Activities
 http://nlvm.usu.edu/en/nav/frames_asid_316_g_1_t_4.html?
 from=category_g_1_t_4.html
 http://nlvm.usu.edu/en/nav/frames_asid_317_g_1_t_4.html?
 from=category_g_1_t_4.html
 http://nlvm.usu.edu/en/nav/frames_asid_318_g_1_t_4.html?
 from=category_g_1_t_4.html

Looking down and around with richard diebenkorn

• •

RICHARD DIEBENKORN (1922-1993) was an American abstract expressionist who was born in Portland, Oregon, but who grew up in San Francisco, California. At the very early age of four, Diebenkorn took to drawing. In 1943, Diebenkorn joined the marines and, during World War II, he served as a mapmaker, which probably influenced his art. It was the paintings and drawings created from 1953 to 1955 from Diebenkorn's *Berkeley* period that earned him recognition as an abstract artist of unparalleled ability. During his career, Diebenkorn taught at the California School of Fine Arts, the University of Illinois at Urbana, and UCLA. Diebenkorn is best known for his *Ocean Park* series, a collection of more than 140 paintings, which look like aerial landscapes, and which were named after a community in Santa Monica, California where his studio was located. Diebenkorn was awarded the National Medal of Arts in 1991 for his outstanding contributions in arts.

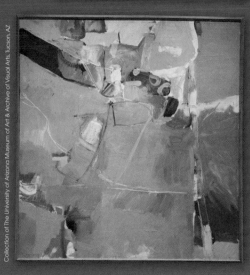

Collection of The University of Arizona Museum of Art & Archive of Visual Arts, Tucson AZ

↗ Richard Diebenkorn, *Berkeley #19* (1954). Ogle how Diebenkorn incorporated the elements of line, shape, color, value and texture in this work.

ƒaⅼcinating factⅼ

- Diebenkorn received an undergraduate degree in art from Stanford University in 1949.
- Diebenkorn served as a faculty member at the California School of Fine Arts, the University of Illinois at Urbana, and UCLA.

FAMOUS QUOTES
" It is not a matter of painting life. It's a matter of giving life to a painting. "

" All paintings start out of a mood, out of a relationship with things or people, out of a complete visual impression. "

MASTERPIECES TO OGLE
Berkeley No. 52 (1955)
Ocean Park No. 129 (1984)
Cityscape I (1963)
Combination (1981)

ART CONCEPTS/SKILLS: abstract expressionism, line, shape, perspective

MATH CONCEPTS/SKILLS: line, shape, perspective, scale, spatial reasoning

WHAT YOU'LL NEED
- posterboard
- ruler
- tempera paints, watercolors, crayons, or markers

LET'S HAVE FUN!
Have you ever flown on an airplane and looked out the window to spy the earth below? Does the ground below sometimes look like individual rectangular and square plots of land of different colors? If you have never flown, can you imagine yourself as a bird flying over a

large piece of land, looking down at the landscape below, or, being on the top of a very tall building looking down at the ground beneath you? This is what we mean by a *bird's eye view* perspective; that is, you are looking down as if from above. By manipulating space (one of the seven elements of art), an artist creates perspective.

View, enjoy, and discuss some of Richard Diebenkorn's works of art; in particular his works in his *Berkeley* series and in his *Ocean Park* series. When you ogle the pieces of art in these series, do you think they look like what a bird might see if it were flying overhead? What do you think Diebenkorn was spying from his aerial view when he painted *Berkeley #19*? What aerial images do you see in this piece of art? What aspects of Diebenkorn's work do you like? What elements of art do you see in his creations?

Create your own landscape with a bird's eye view perspective in the spirit of Richard Diebenkorn. Look out an upstairs window so that you are viewing the ground below. Or, close your eyes and imagine you are at the top of a mountain looking down at the earth below. Create distinct regions of color on your posterboard that capture the colors you see below. If you want, use a ruler to help you outline and define any square or rectangular regions you see.

↗ *A Blue View from the Air;* From her bird's eye view, Kate (age 7) spied the ocean, some grass, and colorful circus tents below.

put on your Math goggles!

Believe it or not, map-making and map reading both involve a multitude of mathematics. For example, when creating a map, you need to define the map's *scale;* that is, the relationship between distances on the map and the corresponding distances on the earth's surface. The scale of a map is usually expressed as a *fraction* or a *ratio.* For example, one centimeter on the map might represent five miles on the ground. Also, you might see *lines* of latitude and longitude, which are measured in *degrees.* Cities and towns are defined on a map by a *point* and any location on a map can be defined by its unique *coordinates.* All of these words: scale, fractions, ratio, lines, degrees, point, coordinates are mathematical terms!

With younger children: Ask your child to count how many colors he/she used in their aerial landscape. Also, ask him/her to count how many square, rectangular or other shaped regions they painted. Which region is the largest? The smallest?

Using the Mapblast website listed below, zoom in and out of your home address and help your child understand direction (north, south, east, and west) as well as where their home is located, relative to their city, to their state, to the U.S., and beyond.

Gently introduce your child to the Cartesian coordinate system by printing off a map of your neighborhood and tracing paths along streets (moving up and down, and left and right) from their home to their school, to the local fire station or library, to their favorite park or store, etc.

With older children: Just as with younger children, visit the Mapblast website (listed below), and make a map of your home address. Look for the scale on your map and explain to your child how it works. For example, if one inch represents three miles, then two inches represents six miles, etc. Challenge your child to estimate the distances between two locations, say between home and school, etc. Watch how the scale of the map changes, as well as what details appear, as you adjust the zoom feature on Mapblast.

Using a globe, locate and trace with your finger the lines of latitude and longitude. Show how each city on the globe is uniquely identified by its latitudinal and longitudinal coordinates. Can your child find his/her hometown or state capital on a globe? Knowlton's and Taylor's books (listed below) are good resources for understanding all of the information appearing on maps and globes.

BOOKS TO OGLE

As the Crow Flies: A First Book of Maps by Gail Hartman
Find out what a map might look like from the perspectives of an eagle, rabbit, crow, horse, and gull.

Where Do I Live? by Neil Chesanow
Help your child gain a sense for their place in this big world by taking them from their home, and then step-by-step all the way out to their place in space, and then back again.

Me on the Map by Joan Sweeney
Follow a young girl step-by-step, as she moves from a map of her room, to a map of her house, to a map of her street…and eventually to a map of her world…and then back again!

My Map Book by Sara Fanelli
Enjoy maps drawn from a child's perspective.

Mapping Penny's World by Loreen Leedy
Learn the basics of map-making as a young girl makes a map of her dog's world.

Maps and Globes by Jack Knowlton
Learn a brief history of mapmaking and some of the terms associated with maps and globes.

Maps and Mapping by Barbara Taylor
Learn all about the features of maps, including scales, contour lines, the use of color and symbols, and more!

The Man Who Walked Between the Towers by Mordicai Gerstein
You will be amazed to hear how a French trapeze artist maintained his balance and walked a mile high above New York City! Wait until you see the book's dizzying illustrations, sketched from various viewing perspectives.

WEBSITES TO OGLE (PLEASE VIEW BEFORE SHOWING TO YOUR CHILD
IN CASE CONTENT HAS CHANGED.)

Richard Diebenkorn Catalogue Raisonné
 http://www.diebenkorn.org/

John Berggruen Gallery–Richard Diebenkorn
 http://www.berggruen.com/exhibitions/2003-03-19_richard-
 diebenkorn/#/artists/richard-diebenkorn/

MoMA–The Collection–Richard Diebenkorn
 http://www.moma.org/collection/browse_results.php?criteria=O%3
 AAD%3AE%3A1539&page_number=1&template_id=6&sort_order=1

Mapblast
 http://www.mapblast.com

Clementine Hunter's Folk Art 1, 2, 3

CLEMENTINE HUNTER (1886-1988) was an African-American self-taught folk artist born on a cotton plantation near Cloutierville, Louisiana. Although she did not begin painting until in her fifties, it is estimated that Clementine Hunter created as many as five thousand pieces of art during her lifetime. Her artistic talent was noticed and later promoted by Francois Mignon, a journalist and curator of buildings and gardens at Melrose Plantation, where Clementine worked. Plantation life was difficult and this was evident in her works. Because Clementine did not always have canvas on which to paint, she would use old discarded materials, such as window shades, jugs, cardboard, brown paper bags, and even gourds. Despite becoming a folk art legend as well as a social historian for capturing portrayals of plantation life, Clementine Hunter spent her entire life in or near poverty.

National Museum of Women in the Arts, Washington, DC

↗ Clementine Hunter, *Call to Church and Flowers* (1970). Ogle Hunter's playful use of color, value, line, and shape.

fascinating facts

- Clementine Hunter was the first African-American artist to have a solo exhibition at the Delgado Museum, now called the New Orleans Museum of Art.
- Hunter co-authored *Melrose Plantation Cookbook* with Francois Mignon.

FAMOUS QUOTES

"I tell my stories by making pictures."

"I paint the story of my people…My paintings tell how we worked, played and prayed."

MASTERPIECES TO OGLE

Pickin' & Haulin' Cotton (1950)
Baptismal (1976)
Gourds (1950)
Wedding (1976)

ART CONCEPTS/SKILLS: folk art, color

MATH CONCEPTS/SKILLS: counting, skip counting

WHAT YOU'LL NEED

- discarded material (such as an old shade, paper bag, cardboard, etc.)
- paints, crayons, or markers

LET'S HAVE FUN!

View, enjoy, and discuss some of Clementine Hunter's works. Do you like her folk art? Do you like its child-like nature and simplicity? What do you think life was like for the people pictured in her paintings? What elements of art do you see in her paintings?

Ogle Hunter's *Call to Church and Flowers*. What time of day do

you think it is? What season? Who is doing the calling to church? How is the calling happening? Where are the people?

Create your own folk art in the spirit of Clementine Hunter. Think about what life might have been like living on a plantation in the early 1900s. Read one of the suggested books below about the life and artwork of Clementine Hunter to stir some ideas. Or, talk to one of your grandparents or ancestors about how life was for them decades or a century ago and paint images of what you learn. This is what folk art is all about: capturing a day in the life of a group of people.

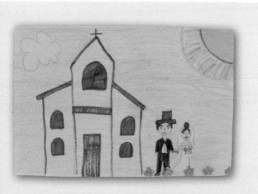

↗ *Summer Wedding;* Sienna (age 8) captures wedded bliss on a warm summer day.

Using a piece of discarded material (as would Clementine Hunter), paint a folk art scene— whether it be a day on a plantation or a typical day in your ancestors' lives. Play with color, as did Clementine Hunter! View your folk art and then title it. What elements of art do you see in your work of art?

put on your math goggles!

Let's take a look at Clementine Hunter's work and begin counting!

With younger children: Take a close look at Hunter's *Call to Church and Flowers* (1970). Name all of the objects that you count one of. Next, name all of the objects you count two of, and then three of. Keep going!

Can you count all the images in your folk art? How many do you see?

With older children: Just as with younger children, capitalize on every opportunity that would allow your child to count! Regularly encourage him/her to count by twos, threes, fives, tens, etc. Skip counting will assist him/her with understand-

multiplication, since multiplication is, very simply, repeated addition!

BOOKS TO OGLE

Anno's Counting Book by Mitsumasa Anno
Embark on a counting journey as you find one of everything on the first page, two of everything on the second page, and so on.

Grandpa Gazillion's Number Yard by Laurie Keller
Find out how the numbers 1 through 20 can really come in handy in this cleverly illustrated book with rhyming text.

Arlene Alda's 1 2 3 by Arlene Alda
You will be amazed at how the numerals 1 through 10 are portrayed in this book!

I Spy Two Eyes: Numbers in Art by Lucy Micklethwait
Count from 1 to 20 while viewing masterpieces of art.

Museum 1 2 3 by The Metropolitan Museum of Art
Count from 1 to 10 while viewing some of the masterpieces of art housed at this museum.

Art from Her Heart: Folk Artist Clementine Hunter by Kathy Whitehead
Discover the life and work of Clementine Hunter through lyrical text in this picture book.

Talking with Tebé: Clementine Hunter, Memory Artist by Mary E. Lyons
Learn about the life of the extraordinary artist, Clementine Hunter, called "Tebé" by her family.

Come Look with Me: Discovering African American Art for Children by James Haywood Rolling, Jr.
Learn about and view the artwork of a variety of African American artists.

Clementine Hunter: The African House Murals edited by Art Shiver and Tom Whitehead
Discover just how Clementine Hunter created her colorful murals of plantation life. Several chapters written by prominent experts document the history of Melrose Plantation and Clementine Hunter.

Painting by the Heart: The Life and Art of Clementine Hunter, Louisiana Folk Artist by Shelby R. Gilley
A comprehensive guide to the artist's works.

WEBSITES TO OGLE (PLEASE VIEW BEFORE SHOWING TO YOUR CHILD
IN CASE CONTENT HAS CHANGED.)

Folk Art Life: Clementine Hunter
 http://www.folkartlife.com/articles/clementinehunter.shtml

Clementine Hunter's First Oil Painting
 http://www.clementinehunterartist.com/

The American Folk Art Museum
 http://folkartmuseum.org/index.php?id=874

Jasper Johns' Fancy Flags

JASPER JOHNS, a painter, sculptor, and printmaker, was born in Augusta, Georgia in 1930, but grew up in South Carolina. He is considered a pop artist due to his use of iconographic images, such as flags, targets, letters, and numbers, and he laid the groundwork for Minimalism. Johns' early paintings were created using wax encaustic, meaning he would add color pigments to melted beeswax and then spread it onto a surface. That sounds like fun! Johns was famous for incorporating collaged newspaper cuttings, overpainted in multiple layers into his works, such as in *Flag* (1954-55). Johns was also known to attach three-dimensional objects, such as brooms and rulers to his canvas. He also incorporated everyday objects such as paintbrushes, beer cans, and light bulbs into some of his early sculptures. Johns still produces about four to five paintings a year, and his works are extremely difficult to acquire.

The Museum of Fine Arts, Houston, TX
Art © Jasper Johns/Licensed by VAGA, New York, NY

↗ Jasper Johns, *Ventriloquist* (1983). Who do you think is speaking in this work? The vase, perhaps?

fascinating facts

- In 1949, Johns was drafted into the Army and stationed in Japan.
- In 1999, Jasper Johns guest starred as himself in an episode of *The Simpsons*.

FAMOUS QUOTES

"Sometimes I see it and then paint it. Other times I paint it and then see it."

"Do something, do something to that, and then do something to that."

MASTERPIECES TO OGLE

Flag (1954-55)
Flag on Orange Field (1957)
Three Flags (1958)
Painted Bronze (1960)

ART CONCEPTS/SKILLS: patterns, line, color, collage, texture

MATH CONCEPTS/SKILLS: patterns, line

WHAT YOU'LL NEED

- wood (cardstock or posterboard will work, too)
- tempera paints, watercolors, crayons, or markers
- newspaper
- glue
- scissors

LET'S HAVE FUN!

View, enjoy, and discuss some of Jasper Johns' works of art; in particular, his works containing images of flags. What elements of art do you see in his creations?

double image of the American flag. But what happened to the red, white, and blue that we know so well? Jasper Johns changed the white in the American flag to be black (the opposite of white); he changed the red in the flag to be green (which is the opposite of red); and he changed the blue to be orange (the opposite of blue). Why do you think he changed the colors on the American flag?

If you look carefully enough, you will see a sliver of the American flag painted using its correct colors, off to the left-hand side of his work. Why do you think it is mostly missing? Also, do you think the door will open in his work, since it has hinges? Is that a vase, or the profiles of two people? What other images do you see in this work... and what do you think they mean?

Create your own flag in the spirit of Jasper Johns. Pretend you were in charge of re-designing the American flag. What would you want it to look like? Or, make a flag that represents you, your school, your family, etc. Consider gluing strips of newspaper to your flag, and then painting over them, in the spirit of Jasper Johns.

View your flag and then title it. What elements of art do you see in your colorful flag?

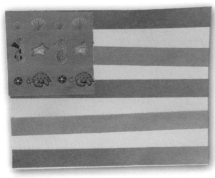

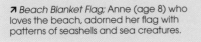

↗ Flag of My Favorite Things; In the spirit of Jasper Johns, Sissy (age 6) included letters and numbers on her flag as well as newspaper clippings of her favorite fruits and flowers. Ogle the many patterns on her flag.

↗ Beach Blanket Flag; Anne (age 8) who loves the beach, adorned her flag with patterns of seashells and sea creatures.

put on Your math goggles!

The American flag is more than just a tri-colored cloth. Put on your math goggles and you will see a patterned image comprised of five rows of neatly positioned white stars in groups of tens, and thirteen horizontal stripes, alternating in a red-white, red-white pattern.

With younger children: View the World Flag Database website listed below and encourage your child to identify and articulate patterns he/she sees in flags. Also, patterns abound in our world, so encourage your child to always be looking for them.

With older children: Just as with younger children, encourage your child to look for and to describe patterns in flags as well as in his/her world.

BOOKS TO OGLE

Where Is Jasper Johns? by Debra Pearlman
Embark on a journey of discovery through a selection of artworks by Jasper Johns.

Pattern Bugs by Trudy Harris
Guess the pattern in the rhyming text and notice patterns in the illustrations of bugs as well.

Pattern Fish by Trudy Harris
Guess the pattern in the rhyming text and notice patterns in the illustrations of fish as well.

Lots and Lots of Zebra Stripes by Stephen Swinburne
See just how many patterns exist in nature!

Patterns in Peru: An Adventure in Patterning by Cindy Neuschwander
Follow a set of twins whose understanding of patterns and sequences helps them to locate the lost city of Quwi.

WEBSITES TO OGLE (PLEASE VIEW BEFORE SHOWING TO YOUR CHILD IN CASE CONTENT HAS CHANGED.)

Jasper Johns' *Ventriloquism*–Museum of Fine Arts, Houston
http://www.mfah.org/exhibition.asp?par1=1&par2=3&par3=79&par4=1&par5=1&par6=1&par7=&lgc=4&eid=¤tPage=

Jasper Johns–A Retrospective - MoMA

http://www.moma.org/interactives/exhibitions/1996/johns/

World Flag Database

http://www.flags.net/indexa.htm

National Library of Virtual Manipulatives–Color Patterns

http://nlvm.usu.edu/en/nav/frames_asid_184_g_1_t_2.html?
from=topic_t_2.html

National Library of Virtual Manipulatives–Pattern Blocks

http://nlvm.usu.edu/en/nav/frames_asid_169_g_1_t_2.html?ope
n=activities&from=topic_t_2.html

jasper johns shades in the states

IN THE PREVIOUS ACTIVITY, we learned about the American painter, sculptor, and printmaker, named Jasper Johns.

In this activity, we see Johns' iconic use of the map of the United States, painted using the primary colors red, blue, and yellow. Let's put on our math goggles and find the math in this piece of art!

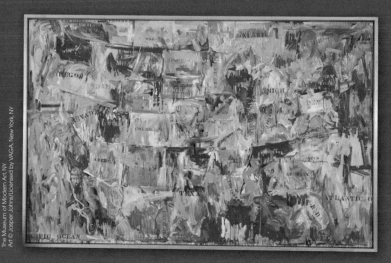

The Museum of Modern Art, NY
Art © Jasper Johns/Licensed by VAGA, New York, NY

↗ Jasper Johns, *Map* (1961). Can you see, count and name all of the states?

fascinating facts

- Jasper Johns knew he wanted to be an artist from age five.
- It is reported that, in 1998, the Metropolitan Museum of Art in New York bought Jasper Johns' *White Flag* (1955) for more than $20 million.

FAMOUS QUOTES

❝Everyone is of course free to interpret the work in his own way. I think seeing a picture is one thing and interpreting it is another.❞

❝As one gets older one sees many more paths that could be taken.❞

MASTERPIECES TO OGLE

Map (1963)
False Start (1959)
White Flag (1955)
Target with Plaster Casts (1955)

ART CONCEPTS/SKILLS: abstract expressionism, color, line

MATH CONCEPTS/SKILLS: line, counting, spatial and directional skills, four color map theorem

WHAT YOU'LL NEED
- map of the United States (see website below)
- watercolors, crayons, or markers

LET'S HAVE FUN!

Ogle *Map* (1961) by Jasper Johns. What do you like about his painting of the United States? Do you like the appearance of this map? Why do you think Johns painted his *Map* this way? What state names are missing? Do you see the names of any oceans on his work of art? What elements of art do you see in his creations?

Create your own rendition of Jasper Johns' *Map*. Print a copy of a map showing the outline of the United States (see website below for one example). Outline each state using a white or black crayon, label your favorite states (or maybe states you have visited, or states where relatives live) with the state's abbreviation, and then begin painting each state. As you paint, the color will adhere to the paper, but not to the crayon outline and lettering, creating a neat effect. Don't worry if the paint seeps outside of the lines, as Jasper Johns himself did not paint within the lines! Once it has dried, consider

putting a second or even a third coat of paint on top of your work, as Johns worked in multiple layers. View and then title your work. What elements of art do you see in it?

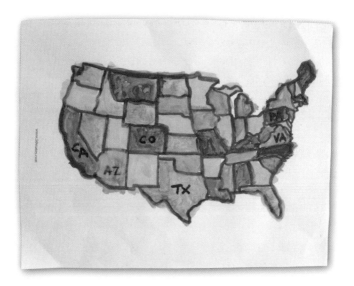

↗ *Where I've Been;* Anna Maria (age 8) painted her states using the primary colors, and green, and then chose to label the states she had visited. She enjoyed having the freedom to paint outside of the lines!

put oN Your MatH goggLef!

Jasper Johns chose to use the primary colors red, blue, and yellow to paint his map of the United States. What colors did you use? Is there a better and more effective way to have painted this map? Read on and find out!

With younger children: Ask you child to count how many colors he/she used in their artwork. Challenge his/her spatial and directional skills (while helping them learn the location and names of states!) by asking them to answer such questions as: Start in Texas and move three states north. Where are you? Or, name two southern states. Or, start in Colorado and move 2 states west and one state south. Where are you?

With older children: Before your child starts painting his/her map in the spirit of Jasper Johns, ask them to fulfill the following requirement: Paint the map using the *least* number of colors and such that no two adjacent (that's a mathematics term that means *bordering* or *sharing a common side*) regions are the same color. So, for example, since Utah and Arizona are adjacent states (that is, they share a common border), they must be painted using two different colors. But, since Utah and New Mexico are not adjacent (as they do not share a common border; they touch only at a point), they could be painted the same color. By the way, this is actually what mapmakers do, as it is important for someone reading a map to be able to discern different and distinct regions and areas. As you paint your map, keep in mind to use the *fewest* number of colors possible!

So what does all of this have to do with mathematics? Read on!

Once your Jasper Johns-like map is complete, count how many colors you used. If you painted the map as described above, you will have only used, at most, four colors. Why? Since the beginning of map-making, cartographers (that's the name for people who make maps) quickly discovered that four seemed to be the magic number when coloring any map, no matter how simple or intricate, such that regions sharing the same boundaries are different colors. Although some maps might only need two or three colors, no map ever needs *more than* four colors. This baffled mathematicians, as well as cartographers, for hundreds of years until it was proven in 1976 through the use of a computer and many hours of hard work. This problem now has a place in mathematical history as the *Four Color Map Theorem.* See the Four Color Map Theorem websites listed below to learn more about this intriguing conundrum!

BOOKS TO OGLE

Where Is Jasper Johns? by Debra Pearlman
Embark on a journey of discovery through a selection of artworks by Jasper Johns.

Maps and Globes by Jack Knowlton
 Learn a brief history of mapmaking and some of the terms associated with maps and globes.
Maps and Mapping by Barbara Taylor
 Learn all about the features of maps, including scales, contour lines, the use of color and symbols, and more!

WEBSITES TO OGLE (PLEASE VIEW BEFORE SHOWING TO YOUR CHILD
IN CASE CONTENT HAS CHANGED.)

Jasper Johns–A Retrospective - MoMA
 http://www.moma.org/interactives/exhibitions/1996/johns/
MoMA–The Collection –Jasper Johns, *Map* (1961)
 http://www.moma.org/collection/object.php?object_id=79372
Blank Outline Map of The United States
 http://www.50states.com/maps/print/usamap.htm
The Story of the Young Map Colorer–The Four Color Math Theorem
 http://www.ccs3.lanl.gov/mega-amath/workbk/map/mpprs-tory.html
The Mathematics Behind Maps–The Four Color Math Theorem
 http://www.ccs3.lanl.gov/mega-math/workbk/map/mpbkgd.html

WASSILY KANDINSKY'S SERENE CIRCLES

WASSILY (VASILY) KANDINSKY (1866-1944) was a 20th century Russian artist known as the father of abstract art. Given his musical background (he learned to play the piano and cello at an early age), it is not a surprise to see the influence of music in his paintings and in the title of his paintings, as Kandinsky believed that painting possessed the same power as music. He studied economics and law at the University of Moscow and, at age 30, Kandinsky abandoned his promising career as a law professor to pursue painting. Kandinsky, who was known for his ingenious use of color and shape, enjoyed using watercolor, gouache, tempera, varnish, bronze and aluminum paint. He even sprinkled sand on his works to produce a granular texture. He painted not only on canvas, but also on boards, wood, plywood, and even glass!

Solomon R. Guggenheim Museum, NY

↗ Wassily Kandinsky, *Several Circles* (1926). How many circles do you ogle?

fascinating facts

- In 1901, Kandinsky, co-founded Phalanx, an association for avant-garde artists. (*Phalanx* means an organized group of people.)
- While teaching at Bauhaus, a German art school, Kandinsky befriended his colleague and fellow painter, Paul Klee.

FAMOUS QUOTES

❝An empty canvas Is a living wonder...far lovelier than certain pictures.❞

❝Everything starts from a dot.❞

❝Color is the keyboard, the eyes are the hammers, the soul is the piano with its many chords. The artist is the hand that, by touching this or that key, sets the soul vibrating automatically.❞

MASTERPIECES TO OGLE

Squares with Concentric Circles (1913)
Improvisation series
Composition series

ART CONCEPTS/SKILLS: abstract art, color, line, shape

MATH CONCEPTS/SKILLS: circles, diameter, circumference, pi, measurement

WHAT YOU'LL NEED

- 8.5" X 11" white paper (cardstock or watercolor paper)
- circular objects to measure and trace
- watercolors (or crayons or markers)
- string
- scissors
- ruler

LET'S HAVE FUN!

View, enjoy, and discuss some of Kandinsky's works. Do you like his style of painting? Do you think his works embody music or make you think of music? What elements of art do you see in his works?

Ogle Kandinsky's *Several Circles*. He sure painted a lot of colorful circles! This is because Kandinsky saw the circle as one of the most peaceful shapes, having a perfect form and representing the human soul.

Create your own Kandinsky in the spirit of his *Several Circles*. Find several circular objects of varying size (e.g., coins, lids, rim of a coffee cup, etc.) and trace them onto a piece of white paper. Draw the circles separate from one another as well as overlapping, as did Kandinsky, and then color your masterpiece. View your work and think of a creative title for it. What other elements of art do you see in your masterpiece?

↗ *Outer Space Bubbles;* Mary Kelly (age 9) thought that her colorful circles looked more like bubbles floating in deep space, as opposed to just circles.

put oN Your Math goggLef!

A circle is a special type of shape that is *not* considered a polygon because a circle is not made up of individual line segments. Mathematically speaking, a circle is a shape that is bounded by a continuous line, which is always the same distance from the center.

With younger children: Circles abound in our world, so encourage your child to look for circles around him/her, as he/she will see many (e.g., wheels on a bike, traffic lights, CDs and DVDs, buttons, a Frisbee, a clock face, etc.). After making his/her masterpiece in the spirit of Kandinsky's *Several Circles,* ask your child to count the number of circles in his/her work.

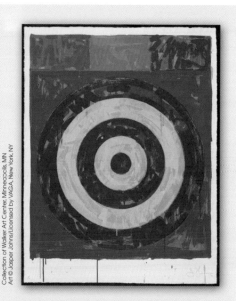

↗ Remember learning about Jasper Johns? Well he was also famous for painting targets, like this one in his Target (1974). Targets feature concentric circles (meaning each circle shares the same center, but vary in size).

Which circle is the biggest? The smallest? Can your child put the circles in order from smallest to biggest?

You will find that, again, approximately three pieces of string the length of the diameter form the circumference of the circular object.

With older children: A very interesting relationship exists between the circumference of a circle and its diameter. Mathematically speaking, the circumference of a circle is the distance around a circle (think about tracing a circle with your finger), while the diameter is a line segment that passes through the center of a circle and has its endpoints on the circle. When you cut a round cookie or pizza in half, you are cutting along one of the circle's diameters. See! You use math everyday!

Those ancient Greeks who wore math goggles discovered that the ratio of the circumference of a circle to its diameter (that is, circumference divided by diameter, which we write as C / d) is equal to approximately 3. It was the great Greek mathematician, Archimedes, who made an even better approximation calling it *pi,* which equals about 3.14, when rounded. So, in other words, no matter how big or how small a circle is, the circumference of a circle is always about 3 times bigger as compared to its diameter. Isn't that neat?

Help your child see that the circumference of a circle is always three times bigger than its diameter. Locate a small circular object (e.g., a plastic lid). Ask your child if, he/she thinks it would take longer for a ladybug to walk across the diameter of the circle (the line segment that divides a circle in half) or to walk all

the way around the circular object (the circumference)?

Cut a piece of string so that it stretches all the way across the circle and through its center, dividing the circle in half. In other words, make a diameter of the circle out of string.

Place this piece of string, along the circular object's edge. Cut another piece of string, measuring the same length as that of the diameter, and place this piece of string on the edge of the circle, end-to-end to the prior one. Ask your child how many more pieces of string, with the same length of the diameter, he/she thinks it will take to wrap around the remaining edge of the circle. Cut another piece of string, the same length as the diameter, and place it touching the other pieces of string situated on the edge of the circular object. Ta da! The three pieces of string, placed end-to-end, nearly wrap all the way around the circle, completing its circumference. Doing this activity is a great way to visually demonstrate to young learners that the circumference of a circle is *always* about three times larger than its diameter.

Repeat this same experiment, but now use a *really* large circle, like a hula-hoop, to see if this same relationship between a circle's circumference and diameter holds true. It will!

This is why, in middle school math, we introduce and use the formula: $C = pi \times d$ (where C is the circumference, d is the diameter, and pi is the constant value equaling about 3.14). So, if you are told that the diameter of a circle is 4 inches, then you know, without doing *any* cutting and measuring, that the circle's circumference is about 12 inches! Mathematics is simply magical!

BOOKS TO OGLE

Circles (Welcome Books' City Shapes Series) by Jennifer Burke
Readers will enjoy finding circles in unusual places.

What Is Round? by Rebecca Kai Dotlich
Rhyming verse accompanies photos of everyday objects that are round.

So Many Circles, So Many Squares by Tana Hoban
See photos of these shapes abounding in a child's everyday world in this wordless book.

The Missing Piece by Shel Silverstein
Enjoy this classic about a circle trying to complete itself.

Sir Cumference and the First Round Table by Cindy Neuschwander
Help the knight, Sir Cumference, and his wife, Lady Di of Ameter figure out how to design a table large enough to hold all of King Arthur's knights. Check out other books by this author with similar titles.

WEBSITES TO OGLE (PLEASE VIEW BEFORE SHOWING TO YOUR CHILD IN CASE CONTENT HAS CHANGED.)

Guggenheim Collection Online– Vasily Kandinsky
http://www.guggenheim.org/new-york/collections/collection-online/show-full/piece/?search=kandinsky&page=2&f=quicksearch&cr=12

National Gallery of Art (NGA Kids): Kandinsky
http://www.nga.gov/kids/kandinsky/

Kandinsky's Improvisations
http://www.wassilykandinsky.net/improvisations.php

National Council of Teachers of Mathematics Illuminations: Circle Tool
http://illuminations.nctm.org/ActivityDetail.aspx?ID=116

Math Warehouse: Interactive Circumference of a Circle
http://www.mathwarehouse.com/geometry/circle/interactive-circumference.php

ALL LineD uP WiTH PAUL kLee

PAUL KLEE (1879-1940) was a Swiss painter and graphic artist, born in a small town near Bern, Switzerland, whose whimsical works are said to embody dreams, music, and poetry. Klee's parents were both trained musicians, his wife was a pianist, and Klee himself was a violinist; thus, it is not a surprise that musical aspects permeate Klee's works, including his paintings' titles. His works seem to possess rhythm and movement in his use of patterns of color and shape and, if you look carefully, you will spot houses, people, birds, and animals (especially cats!) in many of his brilliantly colored masterpieces. Line and color predominate many of Klee's works and Klee often incorporated letters and numerals into his paintings, such as in *Once Emerged from the Gray of Night* (1917-18). In 1920, Klee taught color theory at the Bauhaus school along with his friend, Wassily Kandinsky, and he also taught at Dusseldorf Academy in 1931, until the Nazis, who deemed his work

↗ Paul Klee, *New Harmony* (1936). How many squares do you see? Use multiplication to find out quickly!

"degenerate," dismissed him. Although Klee is considered an abstract artist, his creative style was also influenced by expressionism, cubism, and surrealism.

fascinating facts

- Klee created nearly 10,000 works of art, which included paintings, drawings, and etchings.
- Paul Klee served in the German army during World War I.

FAMOUS QUOTES

"Color and I are one. I am a painter."

"A line is a dot that goes for a walk."

MASTERPIECES TO OGLE

Once Emerged from the Gray of Night (1917-18)
Cat and Bird (1928)
Zitronen (1938)
Fish Magic (1925)

ART CONCEPTS/SKILLS: abstract art, color, value, line, shape

MATH CONCEPTS/SKILLS: shapes, rectangles, addition, skip counting, multiplication, fractions, bar graphs

WHAT YOU'LL NEED

- 8.5" X 11" white paper
- 9" X 12" posterboard
- crayons or markers
- ruler

LET'S HAVE FUN!

View, enjoy, and discuss some of Paul Klee's works. Do you like their humorous, musical, poetic, and child-like qualities? Do you see animals, letters, or shapes? What elements of art do you see in his works?

Ogle Paul Klee's *New Harmony*, which has been described as one of Klee's studies of light and color. The center portion of this work is filled with brighter, lighter colored rectangles, while the bor-

der of this work contains darker, more muted shades of color. This causes an almost radiant effect, like light passing through the center of window.

Create your own work of art in the spirit Klee's *New Harmony.* There are two ways to do this. The easiest might be to use spreadsheet software to create and print a 6 X 7 grid of rectangles. Or, use a pencil and ruler to create a 6 X 7 array of rectangles using horizontal and vertical lines. You will need two copies...read on and find out why! Using crayons or markers, color your squares.

Parents or teachers, work along side your child, replicating his/her same exact color scheme. Ask your child to view his/her work and then title it. Ask, "What elements of art do you see in your Klee-like masterpiece?"

↗ *My Colored Blocks;* Maya (age 5) chose her favorite colors, purple and pink, to begin coloring her grid of rectangles, and then mimicked some of the same color choices of Klee.

put on your math goggles!

There is such a multitude of mathematics in Klee's *New Harmony* that I am not sure where to begin! First of all, notice how the masterpiece is made up of rectangles, which we could count—or use multiplication to *more quickly* compute the total number. That's what multiplication is for! We could also explore fractions (What fraction of your grid is purple? Pink?), create a bar graph sorted by color, and explore symmetry. In fact, do you see the symmetry in Klee's *New Harmony*? It's not readily obvious. So, get those math goggles on and read on!

With younger children: Ask your child to first estimate how many rectangles he/she sees in his/her Klee-like work. Then,

count the rectangles. You can count by ones, but that might take a while, so encourage him/her to skip count by twos, which makes counting faster. How close was his/her estimate?

Ask your child to identify what colored rectangle shows up the most. The least? Are there two colors that are used the same amount? Is there a quicker way we could determine which color is used the most and the least? There sure this!

Take the Klee-like masterpiece the *adult* made and cut it into 42 individual rectangles. (This is why I asked the parent *and* child to create the exact same piece of artwork...as I doubt any child would want to cut apart their masterpiece!)

↘ With the help of her teacher, Maya (age 5) constructed a bar graph, sorted by color, using the rectangles from her Klee-like masterpiece.

Help your child to create a bar graph, sorted by color, by stacking like-colored rectangles in vertical columns (or horizontal rows) and gluing them onto a piece of paper. Ask your child questions requiring him/her to interpret his/her bar graph; for example, which color was used the most? The least? Isn't it easier to answer these same questions when viewing a bar graph, as opposed to ogling these rectangles scattered about the colored grid? This is why we use bar graphs in mathematics *and* in the real world, because bar graphs visually organize our data for us so that we can easily and quickly interpret it.

With older children: Just as with younger children, encourage older children to first estimate how many rectangles appear in their Klee-like work and then to count them to check their estimates. Encourage them to see that using multiplication will help them more quickly determine how many rectangles there are.

As with young children, create a bar graph sorted by color. Ask your child questions requiring him/her to interpret his/her bar graph. Encourage them to see how using a bar graph helps us to more quickly and accurately answer questions about how many colors are used in relation to one another, as opposed to ogling the colored, unsorted grid.

Now that we have an easy-to-read bar graph, explore fractions with your child. Ask such questions as: What color of your grid is green? (The answer will be some value out of 42, since the grid is made up of 42 rectangles.) What color of your grid is yellow or blue? Does any color cover half of the grid? (If so, then 21 of the 42 rectangles must be all one color.) Does any color cover one-third of the grid? (If so, 14 of the 42 rectangles must be the same color.)

Take a closer look at Klee's *New Harmony.* There is symmetry in it! Do you see it? If not, tighten up those math goggles! *New Harmony* is based on the principle of "bilateral inverted symmetry." What did I just say? More simply put, if you were to cut Klee's work vertically down the middle (that's the "bilateral" part) and then take the right-hand side of the canvas and flip it; that is, rotate it a half turn counterclockwise (that's the "inverted symmetry" part), you will find that the right-hand side of the canvas matches the left-hand side of the canvas. Isn't that magical!

Consider making a *new* masterpiece in the spirit of *New Harmony,* which captures this idea of bilateral symmetry. Then, look around your world for objects that might possess this same type of symmetry.

BOOKS TO OGLE

Paul Klee (Getting to Know the World's Greatest Artists Series) by Mike Venezia

 Learn about the life of Paul Klee in this biography, complete with clever and humorous illustrations and images of the artist's work.

Paul Klee (The Life and Work of... Series) by Sean Connolly

 A Paul Klee biography.

Paul Klee (Artists in Their Time Series) by Jill Laidlaw
 A Paul Klee biography.
Paul Klee: Animal Tricks (Adventures in Art Series) by Christian Rumelin
 Explore Klee's use of color and symbolism in some of his most famous
 works. Includes a brief biography of Klee at the end of the book.
Dreaming Pictures: Paul Klee (Adventures in Art Series) by Juergen
von Schemm
 Explore and enjoy a variety of Klee's most whimsical works and
 hear what kids have to say about them!
Paul Klee (Sticker Art Shapes) by Sylvie Delpech and Caroline Leclerc
 Let your child help the artist, Paul Klee, complete each work by
 placing reusable stickers on each page.
Paul Klee Coloring Book by Prestel Publishing
 Color a variety of Klee's works.
What Is Symmetry? by Mindel and Harry Sitomer
 Enjoy easy-to-read explanations of line, point, and plane
 symmetry.

WEBSITES TO OGLE (PLEASE VIEW BEFORE SHOWING TO YOUR CHILD
IN CASE CONTENT HAS CHANGED.)
Guggenheim Collection Online–Paul Klee
 http://www.guggenheim.org/new-york/collections/collection-
 online/show-full/piece/?search=New%20Harmony&page=
 &f=Title&object=71.1960
Museum of Modern Art–The Collection–Paul Klee
 http://www.moma.org/collection/browse_results.php?artist_
 id=3130
Paul Klee Museum
 http://www.paulkleezentrum.ch/ww/de/pub/web_root.cfm
National Library of Virtual Manipulatives–Bar Graphs
 http://nlvm.usu.edu/en/nav/frames_asid_323_g_1_t_5.html?
 from=category_g_1_t_5.html
 http://nlvm.usu.edu/en/nav/frames_asid_323_g_2_t_5.html?
 from=category_g_2_t_5.html

paul klee's cityscape of stacks and shapes

• •

IN THE PREVIOUS ACTIVITY, we learned about the Swiss painter and graphic artist, Paul Klee (1879-1940) whose seemingly child-like paintings embody the rhythm and movement of music and which include numerals, symbols, people, animals, and shapes. The work of art featured in this activity embodies Klee's love of shapes, shapes, and more shapes, which stack together to form a colorful cityscape. Klee's intensely blue sky and domed buildings capture the climate and architecture in North Africa, where he visited the year he painted this masterpiece.

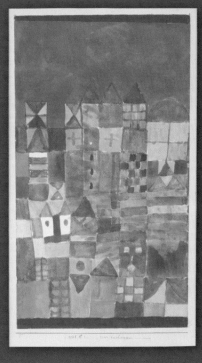

↗ Paul Klee, *Marjamshausen* (1928). Enjoy the water colored lines, colors, and shapes that adorn this captivating cityscape.

The Museum of Fine Arts, Houston, TX

fascinating facts

- Captivated by the light and colors during a brief visit to Tunisia, Klee wrote, "Color has taken possession of me; no longer do I have to chase after it."
- Klee used darker colors and more serious titles in his later works as his health worsened.

FAMOUS QUOTES

❝Art does not reproduce the visible, it makes visible.❞

❝One eye sees, the other feels.❞

MASTERPIECES TO OGLE

Castle and Sun (1928)
Flowers in Stone (1939)
Fugue in Red (1921)
Landscape with Yellow Birds (1932)

ART CONCEPTS/SKILLS: abstract expressionism, shape, line, color, value

MATH CONCEPTS/SKILLS: shapes, patterns

WHAT YOU'LL NEED

- 9" X 12" posterboard
- watercolors, crayons, or magic markers
- 1" to 2" shapes cut from cardboard (such as triangles, squares, and rectangles)—or use everyday objects you can trace

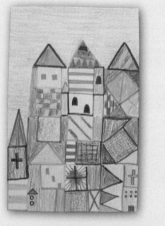

↗ *Magical City in the Sky;* Isabella (age 10) delighted in filling the sky with as many shapes and vibrant colors as possible in this magical work of hers.

LET'S HAVE FUN!

View, enjoy, and discuss some of Paul Klee's works. Do you like their humorous, musical, poetic, and child-like qualities? Do you see animals, letters, or shapes? What elements of art do you see in his works?

Ogle Klee's *Marjamshausen.* What elements of art do you see in Klee's watercolor? Inspired by the light and color of Tunisia, Klee painted this cityscape of overlapping and stacked building facades (fronts of buildings), comprised of simple shapes and sundry colors. What buildings do you see? Would you want to live in this city? Have you ever seen a city so colorful? Could this city be lo-

cated in your neighborhood or state?

Create your own work of art in the spirit Klee's *Marjamshausen.* Hold a piece of posterboard portrait style (vertically) and, starting at the bottom, begin tracing the outline of shapes in various colors of magic marker, stacking one on top of the other as you progress, until you have built the façades of several buildings, making a cityscape. As you color each individual shape, consider designing patterns on some of the shapes, as did Klee in his *Marjamshausen.* View your work and then title it. What elements of art do you see in your Klee-like masterpiece?

 put on Your Math goggles!

Here is a perfect instance of ogling mathematics in art, as shapes abound in Klee's *Marjamshausen!*

With younger children: Without counting, ask your child to estimate the number of shapes he/she used in the creation of his/her Klee-like masterpiece. Next, count the shapes and compare his/her estimate to the actual number. How accurate were your child's estimates?

Ask your child to identify which shape he/she used the most of and the least of. Encourage your child to identify each shape by its name and to describe each shape in terms of its characteristics (e.g., has three sides, all sides are equal, has four corners, etc.). At an early age, encourage your child to use precise mathematical vocabulary when describing shapes.

Also, encourage your child to see the predominance of shapes in architecture. Go outside and take a shape walk with your child and look for and identify shapes in your world! Let him/her experience the magic of mathematics!

Identify and describe any patterns in colors, shapes, etc., that might appear in your child's rendition of *Marjamshausen.* And, of course, always encourage your child to look for patterns in his/her world.

Using the tangrams website (listed below), allow your child to tap into his/her spatial reasoning skills and virtually

manipulate tangrams (a set of seven shapes) to create a variety of people, structures, and things.

With older children: Just as with younger children, estimate, count, and compare the number of shapes used in the creation of his/her artwork. Ask your child to identify the patterns he/she created.

Allow older children to experience the magic and multitude of mathematics by encouraging them to see how shapes and patterns abound in their world and in architecture.

Using the tangrams website listed below, allow your child to tap into his/her spatial reasoning skills and virtually manipulate tangrams (a set of seven shapes) to create a variety of people, structures, and things.

BOOKS TO OGLE

Paul Klee (Getting to Know the World's Greatest Artists Series) by Mike Venezia
Learn about the life of Paul Klee in this biography, complete with clever and humorous illustrations and images of the artist's work.

Paul Klee (The Life and Work of... Series) by Sean Connolly
A Paul Klee biography.

Paul Klee (Artists in Their Time Series) by Jill Laidlaw
A Paul Klee biography.

Paul Klee: Animal Tricks (Adventures in Art Series) by Christian Rumelin
Explore Klee's use of color and symbolism in some of his most famous works. Includes a brief biography of Klee at the end of the book.

Dreaming Pictures: Paul Klee (Adventures in Art Series) by Juergen von Schemm
Explore and enjoy a variety of Klee's most whimsical works and hear what kids have to say about them!

Paul Klee (Sticker Art Shapes) by Sylvie Delpech and Caroline Leclerc
Let your child help the artist, Paul Klee, complete each work by placing reusable stickers on each page.

Paul Klee Coloring Book by Prestel Publishing
Color a variety of Klee's works—and put your own spin on it!

Shapes, Shapes, Shapes by Tana Hoban
See photos of many shapes abounding in a child's everyday world in this wordless book.
Welcome Books' City Shapes Series by Jennifer S. Burke
See real life examples of squares, rectangles, triangles, and even more in a city.
Grandfather Tang's Story: A Tale Told with Tangrams by Ann Tompert
Enjoy a watercolored folktale while manipulating tangrams.

WEBSITES TO OGLE (PLEASE VIEW BEFORE SHOWING TO YOUR CHILD
IN CASE CONTENT HAS CHANGED.)

Guggenheim Collection Online–Paul Klee
http://www.guggenheim.org/new-york/collections/collection-online/show-full/piece/?search=New%20Harmony&page=&f=Title&object=71.1960

Museum of Modern Art–The Collection–Paul Klee
http://www.moma.org/collection/browse_results.php?artist_id=3130

Paul Klee Museum
http://www.paulkleezentrum.ch/ww/de/pub/web_root.cfm

National Library of Virtual Manipulatives–Tangram Puzzles
http://nlvm.usu.edu/en/nav/frames_asid_268_g_1_t_3.html?open=activities&from=topic_t_3.html

Roy Lichtenstein's
Bountiful Benday Dots

↗ Roy Lichtenstein, *Reverie from 11 Pop Artists, volume II* (1965). Ogle Lichtenstein's use of line and the primary colors in this comic book-looking work. Who do you think she is singing to?

ROY LICHTENSTEIN (1923–1997) was a 20th century American Pop artist, born in New York City, whose most famous works feature large scale Benday dots, which became his trademark style. Benday dots, a printing process named after its inventor, Benjamin Day, are two or more small, colored dots closely or widely spaced to create shades of colors and the secondary colors. Lichtenstein, who regularly used stencils to create his Benday dots, derived his ideas for his artwork from comic strips, newspapers, advertisements, and bubble gum wrappers. This is what Pop artists did—they obtained their ideas from images in the mass media and entertainment world. One of his first comic strip-like works was of Mickey Mouse and Donald Duck. Story goes that one of Lichtenstein's sons was playfully taunting him, doubting his ability to paint a picture as good as the ones in his Mickey Mouse comic book.

fa**f**cinating fact**f**

- Lichtenstein served three years in World War II.
- Not only was Lichtenstein a talented painter, but he also created screenprints, sculptures, lithographs, wallpaper, gift wrap, paper plates, and donated benefit prints and posters for social and political causes.

FAMOUS QUOTE

"Picasso himself would probably have thrown up looking at my pictures. "

"Pop Art looks out into the world. It doesn't look like a painting of something, it looks like the thing itself. "

MASTERPIECES TO OGLE

Whaam! (1963)
Crying Girl (1963)
Mustard on White (1963)
Interior with Skyline (1992)

ART CONCEPTS/SKILLS: pop art, Benday dots, primary and secondary colors, line, texture

MATH CONCEPTS/SKILLS: estimation, counting, fractions, multiplication

WHAT YOU'LL NEED

- colored, newspaper comic strip
- magnifying lens
- Perler beads' peg board
- white paper
- crayons
- thick colored markers

LET'S HAVE FUN!

Ogle Benday dots for yourself by using a magnifying lens and viewing a colored newspaper comic strip. Can you see the tiny individually colored dots that, when viewed from afar, create a shade of color or different colors?

↗ Roy Lichtenstein, *Mr. Bellamy* (1961)

Modern Art Museum of Fort Worth

View, enjoy, and discuss some of Lichtenstein's works. What elements of art do you see? Do you like how some of his works, like *Reverie from 11 Pop Artists, volume II* and *Mr. Bellamy* resemble comic strips?

Notice the use of Benday dots in *Reverie from 11 Pop Artists, volume II.* The woman's face appears like a soft peach-ish color but, when viewed up close, you see that it is composed of uniformly spaced, tiny red dots on a white background. This is how Benday dots work—they give you the illusion of other secondary colors.

Also, ogle at how Lichtenstein heavily used the element of line in *Reverie from 11 Pop Artists, volume II* and in *Mr. Bellamy,* and how he limited his color palette to black, white, and the primary colors (red, yellow, and blue). He consciously did this as a means to imitate comic book illustrations and commercial printing methods.

Lichtenstein was a Pop artist, and Pop artists captured familiar images from popular culture that appeared on billboards and in magazines, comic strips, and supermarket advertisements. Look around and locate an everyday, household item. Maybe it is a box of cereal, a coffee mug, or a tube of toothpaste. Sketch the item onto your white paper and then outline it like Lichtenstein would, using a thick black line. Don't color inside the lines yet!

Let's create what looks like Benday dots! Place your outlined, Pop art picture on top of a Perler peg board, which is a small plastic board made up of very short pegs. (See the Perler Beads website below to see what one of these peg boards looks like. They are inex-

pensive and available at most craft stores.) Hold your crayon at an angle and move it swiftly across the paper, pressing firmly down on the peg board. Try not to let your paper slide! The result will be many tiny colored, uniformly spaced dots. If you want, consider mimicking Lichtenstein's technique of making some portions of your picture dotted, and others a solid color (without using the Perler board). View your work of art and title it.

Explore the element of art called *texture* by moving your fingertips lightly across the colored dots. Does your picture feel smooth? Bumpy? Do you see any other elements of art in your masterpiece?

↗ *Time for Breakfast!;* Sophia (age 7) captured the spirit of Pop art by illustrating a picture of what she might eat at breakfast. Ogle all of those tiny dots!

 put oN Your Math goggLeſ! ·······················

Although I am not sure if Lichtenstein ever considered counting the dots in his works, that doesn't mean we can't!

With younger children: Ogle a very small dotted region on your child's masterpiece and ask him/her to first visually estimate how many dots he/she sees. For example, does he/she

see 10 dots? 20 dots? 50? 100? Since the dots are rather small to count precisely, assess your child's estimate for accuracy. How reasonable was his/her estimation?

Consider comparing two different regions of colored dots and ask your child which region has a greater (or smaller) number of dots. Encourage him/her to make visual comparisons. Do any two regions look like they might contain approximately the same number of dots? Make your best visual estimate.

With older children: Explore fractions by asking questions such as: What fractional portion of your Pop art is comprised of red dots? Yellow? etc.

Look for regions where you can apply and practice multiplication. For example, approximately 22 red dots (2 columns with 11 dots in each) appear on the right side panel of the milk carton. If there are approximately 8 more regions of 22 dots on the front of the milk carton, how many dots are there in all? (The answer would be 8 X 22 = 176 dots).

BOOKS TO OGLE

Roy Lichtenstein (Getting to Know the World's Greatest Artists Series) by Mike Venezia

Learn about the life of Roy Lichtenstein in this biography, complete with clever and humorous illustrations and images of the artist's work.

Roy Lichtenstein: The Artist at Work by Lou Ann Walker

An authentic and intimate look at life and works of the artist, Roy Lichtenstein.

The Dot by Peter Reynolds

A teacher's encouragement turns a frustrated art student into a competent and confident artist.

A Million Dots by Andrew Clements

Really! This book contains a million dots—along with interesting facts. Get ready to count!

Museum 1 2 3 by The Metropolitan Museum of Art

View masterpieces of art housed at the Metropolitan Museum of Art while counting from 1 to 10.

I Spy Two Eyes: Numbers in Art by Lucy Micklethwait
Count all that you see in works of art, from 1 to 20.

WEBSITES TO OGLE (PLEASE VIEW BEFORE SHOWING TO YOUR CHILD
IN CASE CONTENT HAS CHANGED.)
Roy Lichtenstein Foundation
http://www.lichtensteinfoundation.org
Perler Beads Peg Boards
http://www.eksuccessbrands.com/perlerbeads/productlist.htm?bid=299

pAtterN∫ ruN AMok with HeNri MAti∫∫e

• • • • • • • • • • • • • • • • • •

↗ Henri Matisse, *Woman in a Purple Coat* (1937). Ogle all of those lined patterns!

HENRI MATISSE (1869-1954) was a 20th century French painter and sculptor, born in northern France, who was the leader of a short-lived art movement called Fauvism. Translated in French as "wild beasts," Fauve artists were known for their unorthodox (that means unconventional, atypical) use of extraordinarily vibrant colors. Matisse discovered his love of painting when his mother bought him art supplies while he was recovering from appendicitis. Soon, Matisse abandoned his career as a lawyer and enrolled in Parisian art schools. Matisse was a master at using the element of line to capture the movement of the human body. He also loved patterns and placing patterns within patterns in his works. Due to failing health in his later years, Matisse was bound to a wheelchair. Thus, he began a new technique of creating art that he called "drawing with scissors." With the help of his assistants, Matisse created paper collages (also called *gouaches découpés*), many on a large scale, by cutting out brightly colored pieces of paper and then asking his assistants to move them around on the walls of his studio until he liked their placements. Then, the pieces were glued into place. One of Matisse's final projects was the design of a French church, including its interior, decorations, and stained glass windows.

fascinating facts

- In 1888, Henri Matisse passed the bar exam with distinction.
- Matisse is known as the "King of Color."

FAMOUS QUOTES

❝ Drawing is putting a line (a)round an idea. ❞

❝ Seek the strongest color effect possible. ❞

MASTERPIECES TO OGLE
The Family of the Artist (1911)
La Fougere Noire (1948)
La Gerbe (1953)
The Dance (1910)

ART CONCEPTS/SKILLS: Fauve art, line, color

MATH CONCEPTS/SKILLS: line, patterns

WHAT YOU'LL NEED
- white paper
- crayons or markers

LET'S HAVE FUN!
View, enjoy, and discuss some of Henri Matisse's works. Given his use of vibrant colors, it is understandable why Matisse was labeled a fauve artist. Do you like his choice of bold colors? Other than color, what elements of art do you see in his works?

Ogle Matisse's *Woman in a Purple Coat*. What patterns do you see? In this colorful work, there are patterns, patterns

↗ *Pretty in Patterns;* Lily (age 6) included a multitude of patterns in this picture of herself. What patterns do you see?

everywhere! Ogle the patterns of solid lines, dashed lines, squiggly lines, curved lines, floral patterns, and more! Do you see patterns on your clothes or anywhere around you?

Create your own Matisse-like work by making a sketch of yourself in a purple coat. Think like Matisse and use as many patterns as you can as you create your masterpiece. Your patterns can be alternating colors or shapes, patterns of curvy or straight lines, polka dots, etc. View your work and then title it. Did you use any other elements of art in the creation of your masterpiece?

put on your Math goggles!

Patterns permeate mathematics. In fact, it has been said that mathematics is the science of patterns.

With younger children: Encourage your child to look for patterns in his/her world. For example, can he/she find a colored pattern or a pattern of alternating shapes, maybe on a rug or on a piece of clothing? How about numeric patterns (say, in a house number, like 1212 Elm Street)? Once you start viewing your world through your math goggles, you will see a multitude of patterns!

Using numbers, symbols, letters, blocks, buttons, etc., create patterns and challenge your child to guess what comes next. See if your child can create his/her own patterns and challenge you to guess what comes next.

With older children: Just as with younger children, encourage older children to look for patterns in their world. They will probably notice and discern even more intricate patterns.

↗ What kinds of patterns do you ogle in Wayne Thiebaud's *Yo-Yos* (1963)?

BOOKS TO OGLE

Henri Matisse (Getting to Know the World's Greatest Artists Series) by Mike Venezia
> Learn about the life of Henri Matisse in this biography, complete with clever and humorous illustrations and images of the artist's work.

Henri Matisse: Drawing with Scissors by Keesia Johnson and Jane O'Connor
> Biography of the life of the fauve artist.

A Bird or Two: A Story about Henri Matisse by Bijou Le Tord
> A delightful tribute to Matisse, via colorful illustrations, poetic text, and quotes from and about Matisse.

When Pigasso Met Mootisse by Nina Laden
> Enjoy this humorous tale, based loosely on the real-life relationship between the two artists, Picasso and Matisse, complete with illustrations that mimic the work of these famous artists.

Color Your Own Matisse Paintings by Muncie Hendler
> Pretend to be a fauvist and experiment with bold, vibrant, colors!

Dots, Spots, Speckles, and Stripes by Tana Hoban
> Discover and enjoy photographs of these many patterns abounding in your world in this wordless book.

Lots and Lots of Zebra Stripes by Stephen Swinburne
> Enjoy photographs of patterns in nature.

WEBSITES TO OGLE (PLEASE VIEW BEFORE SHOWING TO YOUR CHILD IN CASE CONTENT HAS CHANGED.)

Henri Matisse and the Fauve Artists
> http://www.nga.gov/feature/artnation/fauve/index.shtm

National Library of Virtual Manipulatives–Color Patterns
> http://nlvm.usu.edu/en/nav/frames_asid_184_g_1_t_2.html?from=topic_t_2.html

National Library of Virtual Manipulatives–Pattern Blocks
> http://nlvm.usu.edu/en/nav/frames_asid_169_g_1_t_2.html?open=activities&from=topic_t_2.html

HeNri MAtiʃʃe'ʃ ʃNeAky ʃNAiL ʃpirAL

•••

IN THE PREVIOUS ACTIVITY, we learned about the French painter and sculptor Henri Matisse (1869-1954) and his love of patterns. The work featured in this activity, which he "painted with scissors," was completed a year before he died when he was not in good health. In this remarkably large work, you can discern the spiral pattern of a snail's shell if you follow the curved arc made by the vibrantly colored, cut and torn pieces of paper. Put on your art goggles and ogle the silhouette of a tiny purple snail crawling along the top left corner!

↗ Henri Matisse, *The Snail* (1953). The colors in this abstract arrangement capture the brilliant colors of the Mediterranean landscape, where Matisse lived.

Photo: © Tate London 2011

faʃcinAting factʃ

- Henri Matisse and the artist, Pablo Picasso, despite being rivals professionally, shared a life-long friendship.
- Matisse's *The Snail* measures nine feet by nine feet square—in huge contrast to the tiny creature!

FAMOUS QUOTES

"The paper cutouts allow me to draw with color."

"Creativity takes courage."

MASTERPIECES TO OGLE

The Sorrows of the King (1952)

Icarus (1947)

Blue Nude II (1952)

ART CONCEPTS/SKILLS: Fauve art, line, color

MATH CONCEPTS/SKILLS: lines, curves, spiral patterns

WHAT YOU'LL NEED

- 8.5" X 11" white card stock cut into an 8" X 8" square
- four strips of orange construction paper (measuring about 8" X ½" each)
- 10 - 12 cut or torn pieces of colored construction paper
- one blue rectangle, cut from construction paper, measuring about 1" X 3"
- one green square rectangle, cut from construction paper, measuring about 1" X 1"
- gluestick
- scissors

LET'S HAVE FUN!

View, enjoy, and discuss some of Henri Matisse's works. Do you think he had more fun painting with paint or painting with scissors? Which would you prefer? What elements of art do you see in his works?

Ogle Matisse's *The Snail.* Do you see the spiral of a snail's shell in this piece of artwork? Do you see what might be the body and head of the snail? Why do you think Matisse placed a tiny snail in the top corner of his collage of colored scraps? According to Matisse, he drew the snail "from nature" and, holding it, he became aware of an "unrolling." From there, he took to his scissors.

Create your own Matisse-like work by visiting *The Snail* animated

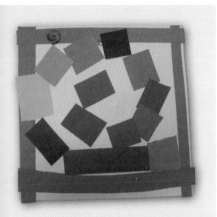

website (listed below), and discovering how Matisse created this colorful collage. Make an orange frame first by gluing four strips of orange construction paper around the perimeter (outer edge) of your white cardstock. Next, glue the large blue rectangle (representing the body of the snail) and then the green square (representing the snail's head) into place, along the bottom edge of the orange frame. Next, place and then glue various sized, cut or torn, colored pieces of paper in a spiral pattern, forming the shell of a snail. Finally, make a sketch of a tiny spiraling snail shell in the top left corner of your masterpiece—loosely mimicking Matisse's snail slithering along the upper left corner of his masterpiece.

View your newly created Matisse-like snail and title it. Encourage your child to trace the spiral pattern of the snail's shell. What elements of art do you see in your masterpiece?

put on your Math goggles! ·························

As mentioned in the previous Matisse activity, patterns permeate mathematics and, so do spirals. Mathematically speaking, a spiral is a curve that begins at a specific point and progressively gets farther away as it revolves around the point. Spirals are fascinating because if you look around you, you will see a multitude of them in your world such as a spiral staircase, the metal spiral binding on a notebook, the spiral design of a nautilus shell or ram's horns, the spiral shape of a tornado or a hurricane. You even have a spiral in your body! The cochlea, which is a part of your inner ear, is spiral-shaped. And, even our Milky Way galaxy is called a spiral galaxy.

See even more examples of spirals by visiting the Spirals in Nature website listed below.

The Museum of Fine Arts, Houston, TX

↗ The artist, Georgia O'Keeffe magnified a spiraling nautilus shell onto a distant landscape in her vibrant, *Red Hills with White Shell* (1938).

With younger children: Ask your child to observe and count the number of pieces of paper in his/her snail shell. Which colored scrap is biggest? Smallest?

Also, encourage your child to look for spirals in his/her world.

With older children: Just as with younger children, encourage older children to look for spiral patterns in their world. Also, explore the websites below and see how a golden spiral can be created inside of a Golden Rectangle.

BOOKS TO OGLE

Henri Matisse (Getting to Know the World's Greatest Artists Series) by Mike Venezia

Learn about the life of Henri Matisse in this biography, complete with clever and humorous illustrations and images of the artist's work.

Henri Matisse: Drawing with Scissors by Keesia Johnson and Jane O'Connor

Biography of the life of the Fauve artist.

When Pigasso Met Mootisse by Nina Laden
 Enjoy this humorous tale, based loosely on the real-life relationship
 between the two artists, Picasso and Matisse, complete with illus-
 trations that mimic the work of both of these famous artists.
Color Your Own Matisse Paintings by Muncie Hendler
 Pretend to be a Fauvist and experiment with bold, vibrant, colors!
Adventures of Penrose - The Mathematical Cat by Theoni Pappas
 Explore a variety of mathematical concepts, including the Golden
 Rectangle, alongside Penrose the cat.

WEBSITES TO OGLE (PLEASE VIEW BEFORE SHOWING TO YOUR CHILD
IN CASE CONTENT HAS CHANGED.)
The Snail by Henri Matisse–(Watch it form!)
 http://www.tate.org.uk/imap/pages/animated/cutout/matisse/
 snail.htm
MoMA – The Collection–Henri Matisse
 http://www.moma.org/collection/artist.php?artist_id=3832
Spirals in Nature
 http://xahlee.org/SpecialPlaneCurves_dir/Spiral_dir/spiral.html
National Library of Virtual Manipulatives–Spiral Designs
 http://nlvm.usu.edu/en/NAV/frames_asid_121_g_1_t_2.html?ope
 n=instructions&from=topic_t_2.html
National Library of Virtual Manipulatives–Spiral in a Golden Rectangle
 http://nlvm.usu.edu/en/NAV/frames_asid_133_g_2_t_3.html?ope
 n=instructions&from=topic_t_3.html

MARIA SIBYLLA MERIAN'S beautiful bugs and butterflies

MARIA SIBYLLA MERIAN (1647-1717) was a scientist and illustrator born in Frankfurt, Germany, who was one of the first naturalists to observe insects directly. Her father, a well-known publisher and engraver, died when Maria was three. Following this, Maria's mom married Jacob Marell, a still life painter, who encouraged Maria to draw and paint. At a young age, Maria was fascinated by bugs and insects, capturing them in boxes and keeping careful records as they grew and transformed. By age eleven, Maria was a skilled engraver and, by 13, she had painted the first images of insects and plants from the many specimens she had captured. By the time Maria reached her thirties, she had published two books on caterpillars. It was Maria's two-year visit to Suriname, located in northern South America, that sealed Maria's place in entomology (the scientific study of insects) and which gained her an international reputation. There, along with her daughter, Maria collected, observed,

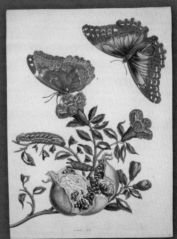

↗ Maria Sibylla Merian, Plate 9 (from "*Dissertation in Insect Generation and Metamorphosis in Surinam,*" (second edition, 1719).

and recorded all types of animals and plants in their natural environment, which she included in her influential book, *Metamorphosis of the Insects of Surinam,* published in 1705. She is considered as much of a scientist as she is an artist.

ƒaƒcinatinɡ factƒ

- The *RV Maria S. Merian,* named after the naturalist and illustrator Maria Sibylla Merian, is Germany's most modern research vessel.
- Merian is considered an artist from the Baroque period.

FAMOUS QUOTES

"In my youth, I spent my time investigating insects."

"I created the first classification for all the insects which had chrysalises, the daytime butterflies and the nighttime moths."

MASTERPIECES TO OGLE

Any of the images appearing in *Dissertation in Insect Generations and Metamorphosis in Surinam* (1719)

Any of the images appearing in *Metamorphosis of the Insects of Surinam* (1705)

ART CONCEPTS/SKILLS: line, symmetry, color

MATH CONCEPTS/SKILLS: line, symmetry, patterns

WHAT YOU'LL NEED

- 9" X 12" white construction paper
- watercolors or tempera paint
- scissors
- magazine
- small hand mirror

LET'S HAVE FUN!

View, enjoy, and discuss some of Maria Sibylla Merian's illustrations of insects and plants. What elements of art do you see in her works?

Ogle Plate 9 (from "*Dissertation in Insect Generation and Metamorphosis in Surinam,*" second edition, 1719). Do you see the

symmetry in the butterfly, the flowers, and in the leaves of the plant?

Create your own work of art in the spirit of Merian. Fold a large sheet of white construction paper in half vertically, Sketch the outline of a butterfly's upper and lower wings on the left side of the paper. Cut along the outline and unfold the paper. You should now have a full butterfly! (Or, check out the Jumbo Butterfly Paper website listed below to order 35"W x 25"H precut butterfly paper.)

Paint the left wing of the butterfly using various colors, lines, dots, and patterns. Work quickly, as you do not want the paint to dry! When you have finished painting the left wing of the butterfly, carefully fold the right-hand side of the paper over the vertical crease and press down on the paper, causing the paint on the left-hand side of the paper transfer to the right-hand side. Slowly and carefully open up the folded paper and enjoy your beautiful, symmetric butterfly! View your work and think of a creative title for it. What other elements of art do you see in your masterpiece?

↗ *Beautiful Butterfly;* Paige (age 5) was elated when she opened up her paper and ogled her symmetrically stunning butterfly.

put on your Math goggles!

Ogle your butterfly and you should see that it is symmetric; that is, what appears on the left-hand side of the butterfly's wing exactly matches the size, shape, colors and patterns on the right hand side of the butterfly's wing. Symmetry is like looking in a mirror—you see an exact image looking back at you.

With younger children: Encourage your child to look for examples of symmetry in the world around him/her, as he/she will see a multitude of examples (e.g., human body, animals, bugs,

airplanes, clothing, flowers, leaves, buildings, flags, etc.).

Find a picture of a symmetric object in a magazine (e.g., a face, building, etc.). Challenge your child to find its line of symmetry; that is, have your child draw a line through the middle of the picture such that it is divided in half, with the left hand side of the picture matching exactly to the right hand side. Let your child check his/her guess by placing a small hand mirror on the line of symmetry he/she just marked. Does he/she see a mirror image of the object?

The Museum of Modern Art, NY

↖ Can you spy all of the line(s) of symmetry in each of the letters in Robert Indiana's *Love, Indiana Stable May 66* (1966)?

With older children: Just as with younger children, encourage older children to look for examples of symmetry in their world.

Ogle Robert Indiana's *Love, Indiana Stable May 66* (1966). Which letters in the word LOVE are symmetric? Can you mark their line(s) of symmetry? Do any of the letters have more than one line of symmetry? Zero lines of symmetry?

Investigate line symmetry in other letters of the alphabet. How many letters have exactly one line of symmetry? Two? More than two? Are any letters *asymmetric*? That is, have no lines of symmetry?

BOOKS TO OGLE

Maria Sibylla Merian: New Book of Flowers by Prestel Publishing
 You will be fascinated by the detail captured by Merian in this collection of her works.

50 Women Artists You Should Know by Christiane Weidemann
 Enjoy biographies and view works of fifty of the most influential women artists (including Maria Sibylla Merian) over the past 500 years.

Monarch Butterfly by Gail Gibbons
 Via captivating illustrations and simple text, enjoy learning about this beautiful (and symmetrical) creature.

Reflections by Ann Jonas
 Follow a boy through his day and then, turn the book upside, and continue reading. Watch how the illustrations are reflected!

What is Symmetry? by Mindel and Harry Sitomer
 Learn the simple facts about the different types of symmetry.

Let's Fly a Kite by Stuart J. Murphy
 See how a savvy babysitter settles sibling squabbles by teaching the concept of symmetry.

WEBSITES TO OGLE (PLEASE VIEW BEFORE SHOWING TO YOUR CHILD IN CASE CONTENT HAS CHANGED.)

National Museum of Women in the Arts
 http://www.nmwa.org/collection/profile.asp?LinkID=588
 http://www.nmwa.org/collection/portfolio.asp?LinkID=588

The Getty Museum: Maria Sibylla Merian & Daughters–Women of Art and Science
 http://www.getty.edu/art/exhibitions/merian/

Jumbo Butterfly Paper
 http://www.discountschoolsupply.com/Product/ProductDetail.aspx?product=23269&keyword=butterfly&scategoryid=0

National Library of Virtual Manipulatives–Reflection Activities
 http://nlvm.usu.edu/en/nav/frames_asid_206_g_1_l_3.html?opcn=activities&from=grade_g_1.html
 http://nlvm.usu.edu/en/nav/frames_asid_297_g_2_t_3.html?open=activities&from=grade_g_2.html

joan miró awakes to shapes!

JOAN MIRÓ (1893-1983) was a Spanish painter, sculptor, and printmaker, who developed his own individualistic style of painting. His works, abstract and inspired by cubism, surrealism, and Dada, were playful and whimsical in nature, and filled with shapes, lines, and fanciful colors. After attending a business college, at his parents' wishes, he worked as a bookkeeper. Sadly, two years later, Miró suffered a nervous breakdown, after which he turned to studying art. Among Miró's most famous works are the small, twenty-three drawings in his *Constellation* series, created between 1939-1941 during a tumultuous time for Miró, who was trapped in France due to the Spanish Civil War and World War II. Miró is known for his "automatic drawing," a technique pioneered by the French surrealist, Andre Masson, where an artist's hand moves randomly and haphazardly across paper as a means of expressing one's deeper, subconscious thoughts and feelings. During his lifetime, Miró won several awards and also produced many mosaics, tapestries, and murals and illustrated over 300 books.

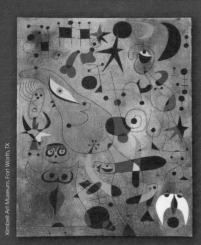

↗ Joan Miró, *Constellation: Awakening in the Early Morning* (1941). If you awoke to this painting, how would you feel?

ƒaſcinating ƒactſ

- Miró produced hundreds of ceramics, including *Wall of the Moon* and *Wall of the Sun* at the UNESCO building in Paris.
- Miró created *The World Trade Center Tapestry,* measuring 20 feet X 35 feet, that hung in the lobby of 2 World Trade Center in New York City until fall, 2001.

FAMOUS QUOTES

"I try to apply colors like words that shape poems, like notes that shape music. **"**

"The spectacle of the sky overwhelms me.**"**

MASTERPIECES TO OGLE

Harlequin's Carnival (1924-25)
Women Encircled by the Flight of a Bird (1941)
The Tilled Field (1923-24)
The Nightingale's Song at Midnight and the Morning Rain (1940)

ART CONCEPTS/SKILLS: automatic drawing, line, shape, color, value

MATH CONCEPTS/SKILLS: points, lines, shapes, polygons

WHAT YOU'LL NEED

- white and black construction paper
- watercolors
- white and black crayon (or marker)

LET'S HAVE FUN!

View, enjoy, and discuss some of Joan Miró's works; in particular, ones in his *Constellations* series. Miró was not painting constellations when creating his *Constellations* series. Instead, he was thinking about the wide-open sky as he painted on his spacious canvas. Do you like Miró's automatic drawings? What elements of art do you see in his works?

Ogle *Constellation: Awakening in the Early Morning.* What do you see in Miró's sky? This work was the fifteenth gouache painting in his *Constellation* series. Gouache (pronounced, "gwash") is a painting technique in which gum is added to watercolors, resulting in the paints drying more quickly and being bolder in color. Ogle the bold reds, yellows, and blues in this work of Klee. Notice the free-floating lines, forms, squiggles, and doodles in this work. This haphazard, playful way of drawing embodies the spirit of automatic drawing.

Create your own work of art in the spirit of Miró. Take a piece of white construction paper, close your eyes and, with a black crayon in hand, begin to move it around on the paper, making dots, lines, and squiggles. Pour your emotions into the movement of the crayon!

Open your eyes and, like Miró, finish your work by connecting any dots and/or completing the outline of shapes. Add more points, lines, or shapes to your masterpiece, if desired. Using watercolors, paint your piece of art (crayons or markers are fine to use as well). View your work and then title it. What elements of art do you see in your Miró-like masterpiece? Do you see any constellations in your work?

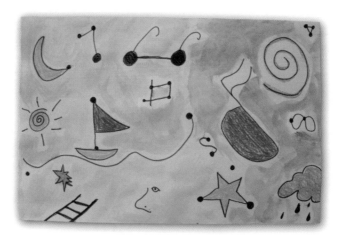

↗ *My Doodle Constellation;* Jesse (age 9) colorfully captures the spirit of Miró in this whimsical work featuring music, numbers, and objects in the sky.

put on your Math goggles!

Constellations are clusters, or groups, of stars that people from ancient civilizations saw in their night sky, which were used as a way for them to make sense of the thousands of stars they would see flickering at night. A total of eighty-eight constellations adorn our northern and southern skies, many of which are named for animals or for mythological characters.

When I view constellations through my math goggles, I see shapes! That's because the stars themselves serve as the points, or corners, to the shapes, and the imaginary lines that form the pattern of constellations are the line segments. When you have points connecting line segments, you get shapes!

With younger children: View your Miró-like masterpiece. Do you see any shapes in your work of art? Describe the shapes you see.

View a map of the night sky using one of the maps on the Monthly Maps of Night Sky website listed below. Do you see any shapes in the constellations? With my math goggles on, I see that Cepheus is a pentagon (five-sided shape), while Bootes is a hexagon (six-sided shape). I even spy what looks like a trapezoid in the constellation, Pegasus.

Make your own constellation! Using Jacqueline Mitton's book listed below for inspiration, choose an animal. Using a white crayon or white chalk, form the outline of your animal constellation by placing several points on a piece of black construction paper, and then connecting the points with line segments. Focus on using several shapes to

↗ Ogle all of the shapes in these student-made constellations named *Buddy the Blood Hound* (Jack, age 6) and *The Slow Snail* (Hannah, age 8).

create your animal constellation. Place a star sticker on each point, making your sketch look even more like a constellation.

Don't forget to put your coat on and, go outside with a parent, and look for constellations in your evening sky.

With older children: Just as with younger children, encourage older children to look for shapes in his/her Miró-like work of art and in the maps of the night sky. Encourage them to create their own animal constellation. Don't forget to go outside and look for constellations in your night sky!

BOOKS TO OGLE

Miró: Earth and Sky by Claire-Helene Blanquet
 A biography of the Spanish artist, Joan Miró.

Miró (Famous Artists Series) by Anthony Mason
 A Joan Miró biography, which includes activities.

Joan Miró (Sticker Art Shapes) by Sylvie Delpech and Caroline Leclerc
 Let your child help the artist, Joan Miró, complete each work by placing reusable stickers on each page.

Zoo in the Sky by Jacqueline Mitton
 You will be captivated by the vibrant and shimmering illustrations of ten familiar animal constellations, each accompanied by poetic text detailing the legend of the constellation.

Coyote Places the Stars by Harriet Peck Taylor
 Enjoy the retelling of a Wasco Indian legend about the origin of the constellations and how a crafty coyote shuffled the stars in the sky using his bow and arrow, creating pictures of his friends.

How the Stars Fell into the Sky by Jerrie Oughton
 Enjoy a beautifully illustrated Navajo tale about the origin of the constellations.

Draw Me a Star by Eric Carle
 Watch as a little boy draws a star, and then a sun, and then a tree, and then a host of other beautiful images. At the end, learn how to draw a really neat star!

Starry Messenger by Peter Sis
 Learn about the life and work of the brilliant astronomer Galileo Galilei in this 1997 Caldecott Award-winning biography.

The North Star by Peter Reynolds
Encourage your child to follow his or her north star in this inspirational story about one's journey through life.
The Sky is Full of Stars by Franklyn Branley
For all of you future astronomers, discover fascinating facts about the stars in your sky.

WEBSITES TO OGLE (PLEASE VIEW BEFORE SHOWING TO YOUR CHILD IN CASE CONTENT HAS CHANGED.)

Fundació Joan Miró (Joan Miró Museum)
http://www.fundaciomiro-bcn.org/
UNESCO Virtual Gallery–*The Wall of the Moon* (1958)
http://www.unesco.org/visit/uk/notices/miro2.htm
UNESCO Virtual Gallery–*The Wall of the Sun* (1958)
http://www.unesco.org/visit/uk/notices/miro1.htm
Monthly Maps of Night Sky
http://www.kidscosmos.org/kid-stuff/star-maps.html
National Library of Virtual Manipulatives–Coloring Shapes
http://nlvm.usu.edu/en/nav/frames_asid_277_g_1_t_3.html?open=activities&from=topic_t_3.html

edvard munch has pier perspective!

• •

EDVARD MUNCH (1863–1944) was Norwegian painter and printmaker born in Oslo, Norway, who is regarded as the pioneer of the Expressionists. Munch's works have been described as dark and frightening and are filled with sorrow and pain, which is not a surprise given that during his lifetime his sister and brother died, along with his wife, mother, father, and aunt, who assumed the role of his mother when she died when Munch was only five years old. In 1879, Munch enrolled in a technical school to study engineering, which is where he learned about scaled and perspective drawing. One year later, due to constant illness, Munch quit school and turned to painting. His most famous and recognizable work, *The Scream* (1893), features an agonized figure against a blood red sky, and has been used in advertising, in movies, and on television.

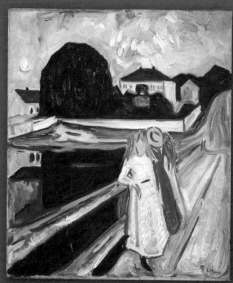

↖ Edvard Munch, *Girls on the Pier* (1904). Ogle the circular shape in the sky. Is it the sun or the moon? Why do we not see its reflection in the water?

fascinating facts

- In 1892, an art show featuring Munch's works was abruptly canceled because observers did not understand the anguish, stress, sorrow, and pain so evident in his paintings.
- During his lifetime, Munch painted over 1,000 paintings, more than 15,00 prints, and over 4,000 drawings and watercolors.

FAMOUS QUOTES

"Death is pitch-dark, but colors are light. To be a painter, one must work with rays of light."

"Without fear and illness, I could never have accomplished all I have."

MASTERPIECES TO OGLE

The Scream (1863)
The Sick Child (1907)
The Day After (1894-95)

ART CONCEPTS/SKILLS: expressionism, line, perspective, shape

MATH CONCEPTS/SKILLS: line, perspective, shape

WHAT YOU'LL NEED

- lined posterboard (or white paper)
- pencil
- ruler
- crayons or markers

LET'S HAVE FUN!

View, enjoy, and discuss some of Edvard Munch's works of art. What do you like about his artwork? What elements of art do you see in his creations?

Ogle Munch's *Girls on the Pier*. What do you think the two girls

Edvard Munch Has Pier Perspective!

on the pier are ogling that the third girl is not? Is there something in the water, in the sky, or something off in the distance toward the hotel that they are ogling? Why is the nearest girl expressionless? Munch created several versions of this painting, all with exaggerated line and color and with a pier receding dramatically into the background space (an element of art!), creating a sense of perspective for the viewer.

Create your own work of art, in the spirit of Munch, using one-point perspective. Follow these instructions or view some of the drawing with perspective websites listed below.

Hold a piece of lined posterboard landscape style (lengthwise). (Note: You can use white paper or cardstock for this activity, but the lined posterboard will help children draw the lines more accurately.) Draw a horizontal line about one inch up from the bottom of the posterboard and across the length of the posterboard. Draw a rectangle whose bottom edge—or base—sits on the horizontal line. This rectangle serves as the façade—or front—of your building.

Place a point somewhere along the top of the posterboard. (Note: When doing this activity for the first time, it works best if the point is located off to the far right (or left) of the rectangle.) This point will be known as the vanishing point. Using a ruler, draw lines (very lightly, as we will erase them later) from the vertices (corners) of your rectangle to the *vanishing point*. (Note: If one of these lines passes through the building, do *not* draw this line.) These lines you just drew are called *convergence lines*.

Decide how "deep" you want your building to be by drawing a horizontal line, parallel to the top edge of your rectangle, between this edge and the vanishing point. Create the side of your building by drawing a vertical line from this newly drawn horizontal line, down to the convergence line. Erase any lines that connect to the vanishing point.

Use crayons or markers to finish the details of your building, by creating windows, doors, awnings, etc. View your one-point perspective, and then title it. What elements of art do you see in your Munch-like masterpiece?

↗ *The Town with Scared Faces;* Brooke (age 10) used one vanishing point to create these three city buildings. Which two buildings seem to have Munch-like startled, frightened looks, due to her placement of their windows and doors? How clever!

put on your Math goggles!

So much of what we did to create our cityscape was mathematics! We drew all types of lines: horizontal, vertical, diagonal, parallel, etc., created shapes, and worked with corners (vertices) and bases. A veritable multitude of mathematics!

With younger children: Look for situations where your child can experience perspective firsthand. For example, look at a road as it disappears into the horizon. The road seems as though it narrows to a vanishing point, changing from rectangular in shape to triangular. But, we know that the road does not narrow or disappear!

With older children: Just as with younger children, seek situations where perspective can be observed. Also, consider making an entire cityscape of buildings using this method of one-point perspective.

View the work of various artists who used perspective in

Edvard Munch Has Pier Perspective!

their works, such as Leonardo da Vinci (*Adoration of the Magi*), Masaccio (*The Holy Trinity*), Donatello (*Feast of Herod*), and Albrecht Durer (*St. Jerome dans sa Cellule*). Can you identify the horizon in the artwork? The location of the vanishing point? The lines of convergence?

View the Powers of 10 website (listed below) and gain an *amazing* perspective of our world, beginning in our Milky Way galaxy and making leaps in powers of 10 down to a microscopic—actually a subatomic—view.

BOOKS TO OGLE

Zoom by Istvan Banyai

As you turn each page, your perspective changes. You move outward, again and again, towards space.

Re-Zoom by Istvan Banyai

Just like its sister book, *Zoom,* as you turn each page, your perspective changes, as you move from space, leap-by-leap, towards earth.

Looking Down by Steve Jenkins

Enjoy your perspective from space!

The Turn-Around, Upside-Down, Alphabet Book by Lisa Campbell Ernst

You have never seen the letters A to Z in these orientations!

Madlenka by Peter Sis

Come along as a young girl named Madlenka announces to everyone she knows in the city that she lost her tooth. Features dazzling illustrations with fascinating perspective.

The Man Who Walked Between the Towers by Mordicai Gerstein

You will be amazed to hear how a French trapeze artist maintained his balance and walked a mile high above New York City! Wait until you see the book's illustrations, sketched from various viewing perspectives.

WEBSITES TO OGLE (PLEASE VIEW BEFORE SHOWING TO YOUR CHILD IN CASE CONTENT HAS CHANGED.)

Munch Museum

http://www.munch.museum.no/?id=&mid=&lang=en

Edvard Munch – *Girls on the Pier* (c. 1901) – MOMA
http://www.moma.org/explore/multimedia/audios/26/595

Incredible Art Lessons–Perspective Drawing
http://www.princetonol.com/groups/iad/lessons/middle/per-spective.htm

Drawing with One Point Perspective
http://www.cartage.org.lb/en/themes/Arts/drawings/PerspectiveDrawing/OnePointPersp/OnePointPersp.htm

Powers of 10
http://micro.magnet.fsu.edu/primer/java/scienceopticsu/powersof10/

georgiA o'keeffe's grAnd sense of scent And scale

• •

GEORGIA O'KEEFFE (1887-1986) was an American painter, born in Sun Prairie, Wisconsin to dairy farmers. She is considered to be one of the most important and successful artists of the twentieth century. At a young age, O'Keeffe's parents enrolled her in art class and her abilities were obvious. Early in her career, O'Keeffe became discouraged with her work and so she began working as an art teacher at an elementary school in Texas. Then, a friend sent her work to a famous gallery owner, named Alfred Stieglitz, who launched her career as an artist. She later married him. While living in New York, O'Keeffe created some of her most famous works: her larger-than-life flowers that enveloped canvasses in brilliant colors. After Stieglitz died in 1946, O'Keefe relocated to New Mexico, where she had visited years earlier, and whose unique landscape and architecture inspired her. During her lifetime, O'Keeffe won many awards for her works of abstraction, and one can view many of her works at the Georgia O'Keeffe Museum in Santa FE, New Mexico.

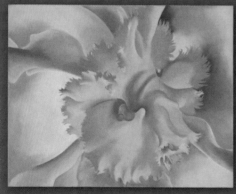

The Museum of Fine Arts, Houston, TX

↗ Georgia O'Keeffe's *An Orchid* (1941). Ogle and enjoy this magnified floral perspective. I sure hope no bumblebees of this grand scale are nearby!

fascinating facts

- O'Keeffe was the second of seven children.
- O'Keeffe was a descendant of Edward Fuller, who was a passenger on the Mayflower and one of the signers of the Mayflower Compact.

FAMOUS QUOTES

"I decided that if I could paint that flower in a huge scale, you could not ignore its beauty."

"I found I could say things with colors that I couldn't say in any other way -- things that I had no words for."

MASTERPIECES TO OGLE

Jimson Weed (1932)
Petunia (1925)
Ram's Head, White Hollyhock-Hills (1935)
Ladder to the Moon (1958)

ART CONCEPTS/SKILLS: line, shape, color, value, perspective

MATH CONCEPTS/SKILLS: lines, shapes, scale, measurement, multiplication

WHAT YOU'LL NEED

- centimeter paper (see website below)
- large white posterboard
- tempura paints (or watercolors, crayons or markers)
- flower (real or silk)
- magnifying lens

LET'S HAVE FUN!

View, enjoy, and discuss some of Georgia O'Keeffe's works; in particular, her close-ups of flowers. Look at those colors! Have you ever

seen flowers this close? Do you get a sense of and a feel for the vast and barren desert when you view some of her works of the New Mexico landscape? What elements of art do you see in her works?

Ogle O'Keeffe's *An Orchid*. You are so close-up on this flower, that you cannot see its stem or leaves and, you barely see the totality of its petals! I wonder what a flower this large might smell like? Did you ever wonder what the inside of a flower might look like? Go outside and take a look! Orchids can be as small as a few inches and sit in the palm of your hand or grow to be five foot giants. I think Georgia painted an adult orchid in this work of art!

↗ *Beautiful Smell;* Sophie (age 9) captured the spirit of Georgia O'Keeffe in her larger-than-life rendering of a purple impatiens.

Create your own grandiose floral work of art in the spirit of O'Keeffe. Find a flower outside and look at it through a magnify lens. Did you ogle features you did not see before because it was not magnified? Describe what you see. Do you know the names of the various parts of a flower?

Take a piece of large white posterboard and begin painting a close-up of your flower. Look at some of O'Keeffe's flowers for inspiration and ideas on perspective. Remember, do not paint what you see (in terms of size) but a much larger, magnified version of what

you see. Let the center and petals of your flower fill your paper! Choose bold, lively colors!

View your work and then title it. What elements of art do you see in your O'Keeffe-like masterpiece? With a flower that large, wouldn't it be wonderful to smell its fragrance?

put on Your Math goggles!

As you painted your O'Keeffe flower masterpiece, you were using mathematics! Really? By painting your flower to be much bigger in size, you were experimenting with something called *scale*.

Think about what you saw when you ogled your flower through the magnifying lens. The flower looked the same, just a whole lot bigger! This is what we mean by *scale*. Depending on the magnification of your lens, the flower might have appeared, or was scaled, to be 10 times, or maybe even 20 times bigger. Scale is important in mathematics because when something is scaled up (made bigger, like an O'Keeffe flower) or scaled down (made smaller, like a map or a blueprint of a house), the before-and-after shape and proportions of the object stay the same and do not become distorted; only the *size* of the object changes. In other words, scaling multiplies the lengths of all of the line segments and curves that make up a shape by the same number, resulting in what mathematicians call a *similar* figure. Similarity preserves angles and ratios of lengths of corresponding line segments. Now that's a multitude of mathematics!

With younger children: Let's gain practice with this thing called *scale* by making a scaled drawing of your flower so that it appears three times bigger. Trace your flower onto the middle of a piece of centimeter paper. Count out three squares in every direction around the flower's outline and re-trace this larger outline. Ta da! Your flower has now been scaled to appear three times bigger!

With older children: Just as with younger children, you

can create a scaled drawing of a flower as described above (where you use centimeter paper to help guide you) or try this: Trace a flower onto a piece of white paper. Using a ruler, measure the length and width each of the flower's leaves, petals, stem, etc. Multiply all of these measurements by three (the scale factor) and now re-draw the flower using these larger, scaled measurements. Your flower should now appear to be three times bigger. I wonder if Georgia O'Keeffe painted her flowers this way...

BOOKS TO OGLE

Georgia O'Keeffe (Getting to Know the World's Greatest Artists Series) by Mike Venezia

Learn about the life of Georgia O'Keeffe in this biography, complete with clever and humorous illustrations and images of the artist's work.

Georgia's Bones by Jen Bryant

Although classified as fiction, this book celebrates the life of Georgia O'Keeffe using lyrical rhyme and beautiful illustrations.

My Name Is Georgia: A Portrait by Jeanette Winter

Through spare, but carefully chosen prose, discover the life of Georgia O'Keeffe.

Through Georgia's Eyes by Rachel Rodriguez

Read a biography of the artist and learn how she saw the world.

Georgia Rises by Kathryn Lasky

Imagine a day in the life of this extraordinary artist.

Cut Down to Size at High Noon by Scott Sundby

Two barbers in the town of Cowlick discover the importance of drawing to scale.

The Reason for a Flower by Ruth Heller

Learn about a plant's life cycle.

The Flower Alphabet by Jerry Pallotta

Find out interesting facts about flowers as you learn the alphabet!

WEBSITES TO OGLE (PLEASE VIEW BEFORE SHOWING TO YOUR CHILD IN CASE CONTENT HAS CHANGED.)

MoMA- The Collection-Georgia O'Keeffe

http://www.moma.org/collection/browse_results.php?criteria=O%3AAD%3AE%3A4360&page_number=11&template_id=1&sort_order=1

Georgia O'Keeffe Museum

http://www.okeeffemuseum.org/

National Library of Virtual Manipulatives-Playing with Dilations

http://nlvm.usu.edu/en/nav/frames_asid_295_g_2_t_3.html?open=activities&from=applets/controller/query/query.htm?qt=scale&lang=en

Printable Centimeter Paper

http://www.teachervision.fen.com/mathematics/printable/6170.html

PABLO PICASSO (1881-1973) was a painter and sculptor, born in Malaga, Spain, who is best known for co-founding the Cubist movement along with fellow painter Georges Braque. Although Picasso attended one of Madrid's best art schools, it was from Picasso's father, who was an artist and an art teacher, that Picasso received a great deal of his training. During his tumultuous life, Picasso moved through his blue period (in which his works were primarily shades of blue, representing his loss and sadness) into his rose period (where his paintings featured more cheerful colors). One of Picasso's most famous works is *Guernica* (1937), his depiction of the brutality of the German bombing of the town by the same name during the Spanish Civil War. When hearing the name Picasso, most people think of his Cubist works, where the images seem like they are shattered, that is, cut up into pieces and rearranged, as if you are viewing the object from different perspectives and angles.

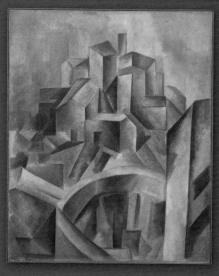

The Museum of Modern Art, NY

↗ Pablo Picasso, *The Reservoir, Horta de Ebro* (1909). Ogle Picasso's use of line, shape, color, form, space, value, and texture. Wow! That's all of the seven elements of art!

fascinating facts

- Picasso's mother claimed that her son's first words were "piz, piz" short for *lapiz,* the Spanish word for pencil.
- Picasso's full name is: Pablo Diego José Francisco de Paula Juan Nepomuceno María de los Remedios Cipriano de la Santísima Trinidad Ruiz y Picasso. Imagine signing that on a canvas!

FAMOUS QUOTES

"Painting is just another way of keeping a diary."

"Every child is an artist. The problem is how to remain an artist once we grow up."

MASTERPIECES TO OGLE

Three Musicians (1921)
Woman in a Blue Hat (1962)
Dora Maar Seated (1937)
The Old Guitarist (1903)
Garcon á la pipe (Boy with a Pipe) (1905)

ART CONCEPTS/SKILLS: line, shape, form, space, perspective, value, texture

MATH CONCEPTS/SKILLS: cubism, line, shape, solids, prisms, polygons, perspective

WHAT YOU'LL NEED

- posterboard
- white paper
- pattern blocks (these would be useful, but not necessary)
- crayons or markers
- gluestick
- scissors
- ruler

LET'S HAVE FUN!

View, enjoy, and discuss some of Pablo Picasso's works of art; in particular his cubist works. Do you like this style of painting? Can you understand what you are seeing? What elements of art do you see in his works?

Ogle *The Reservoir, Horta de Ebro* (1909). Do you see Picasso's abundant use of form (the element of art that refers to three-dimensional figures)? How about Picasso's fascinating and fractured use of space (remember that element of art!). In the spirit of cubism, Picasso places space in front of, behind, and in between forms, and thus, he captures the perspective of looking up a steep hillside at the faceted forms of a village. But the reservoir—the water in green below—suggests he is looking downward. What other elements of art do you see in this work of Picasso? Would you want to live in this mountaintop village?

Create your own hilltop village in the spirit of Picasso's *The Reservoir, Horta de Ebro*. Recall that the hallmark of cubism is the ability of the artist to see objects from different perspectives. With this in mind, place a piece of posterboard portrait style (vertically) and, if they are available, trace some pattern blocks (see website below), positioned at various angles serving at the rooftops to the buildings. (Otherwise, find objects you can trace, or draw shapes freehand.) Using a ruler, drop vertical lines down and at an angle from the vertices (corners) of each roof top shape, creating the sides of the buildings.

Color your cubist village in the spirit of Picasso's *The Reservoir, Horta de Ebro*, and experiment with value, by using shades of terra cotta and gray. If you place a

↗ *Terra Cotta Towers;* Ogle how Lindsey (age 10) traced pattern blocks, which served as the shapely rooftops of the buildings in her terra cotta village.

crayon flat on its side and rub lightly, you can create a "blurred effect," that captures the texture of the stucco in Picasso's work.

For fun, create your own portrait in the spirit of cubism. Look in a mirror and, on a piece of white paper placed portrait style (vertically), draw yourself from a front view. Next, have someone (a friend or parent) draw your side profile on a separate piece of paper, also placed portrait style. Cut along the outline of your side profile and place it on top of one half of your frontal view sketch, forming your entire face. Now color your Picasso-like portrait. View your fractured facial art and then title it. What elements of art do you see in your work of art?

↗ *Terra Cotta Towers;* Lindsey (age 10) thought that the title of her Picasso-inspired masterpiece could be a catchy name for a vacation spot! Would you want to visit this shape-filled resort?

↗ *The Twins;* As Sienna (age 8) colored her partitioned face, she thought about how fun it would be to have two Siennas: one that could go to school, and one that could stay home and play and draw!

put oN Your Math goggleſ!

Now that we are wearing our math goggles, let's carefully ogle Picasso's *The Reservoir, Horta de Ebro* (1909). Many of the shapes

that appear in this work are *solids,* which is a mathematical term for three-dimensional shapes. Three-dimensional shapes are different from two-dimensional shapes because three-dimensional shapes have a length, a width, and a height; that is, they have three parts, or dimensions to them. Two-dimensional shapes (like rectangles, squares, triangles, etc.) only have two dimensions: a length and a width. Think of a piece of paper, (a two-dimensional shape, which is a rectangle) compared to a shoebox (a three-dimensional shape mathematically known as a rectangular prism). Because a shoebox has an extra dimension, you are able to fill it. You can't fill a flat piece of paper!

One family of solids is known as *prisms.* A prism is a special type of solid, which is comprised of a top and bottom base, and the other faces are rectangles. The two bases of a prism are congruent polygons, meaning they are polygons identical in size and shape. A prism is named for its bases. For example, a rectangular prism (e.g., a shoebox) has a rectangle for its top and bottom base, and all of the other faces are rectangles. A hexagonal prism (e.g., a hatbox) has a hexagon for its top and bottom base and six rectangular faces. A triangular prism (e.g., a pup tent) has two triangular bases and its other three faces are rectangles. Check out the Interactive 3D Shapes–Prisms website (listed below) to see more of examples of prisms.

Now that you know a little but about prisms, what prisms do you ogle in Picasso's *The Reservoir, Horta de Ebro* (1909)?

With younger children: Look around your home or the classroom for examples of prisms. Cereal boxes are rectangular prisms, some pencils are hexagonal prisms, some jewelry boxes are octagonal prisms, and Toberlone chocolate comes packed in boxes that are triangular prisms. If you spot a prism, encourage your child to identify the two identical bases and to notice how the other faces of the prism are rectangles.

With older children: Just as with younger children, encourage them to look for and identify prisms in their world.

Also, allow your child to discover the Platonic Solids, first described by Plato in his work, *Timaeus* (350 B.C.E,). Plato

equated each of these solids with what the Greeks called the "elements," namely, the tetrahedron (fire), the cube (earth), the octahedron (air), the icosahedron (water), and the dodecahedron (cosmos). What makes these five solids so unique is that their faces are identical regular polygons. Check out the National Library of Virtual Manipulatives–Platonic Solids website and explore these special solids dynamically.

BOOKS TO OGLE

Picasso (Getting to Know the World's Greatest Artists Series) by Mike Venezia
> Learn about the life of Pablo Picasso in this biography, complete with clever and humorous illustrations and images of the artist's work.

When Pigasso Met Mootisse by Nina Laden
> Enjoy this humorous tale, based loosely on the real-life relationship between the two artists, Picasso and Matisse, complete with illustrations that mimic the work of both of these famous artists.

Picasso and Minou by P.I. Maltbie
> Discover how Picasso's cat, Minou, inspires Picasso to abandon his blue period and to embark on his rose period in this loosely factual story.

Picasso and the Girl with a Ponytail by Laurence Anholt
> An inspirational story about developing self-confidence, complete with Picasso-like illustrations.

Cubes, Cones, Cylinders, & Spheres by Tana Hoban
> Discover and enjoy photographs of these 3D shapes abounding in your world in this wordless book.

Mummy Math: An Adventure in Geometry by Cindy Neuschwander
> Two boys escape from an ancient pyramid by using clues about 3D shapes.

I Spy Shapes in Art by Lucy Micklethwait
> You won't believe how many 2D and 3D shapes you will find!

WEBSITES TO OGLE (PLEASE VIEW BEFORE SHOWING TO YOUR CHILD
IN CASE CONTENT HAS CHANGED.)

MoMA–The Collection–Pablo Picasso

http://www.moma.org/collection/browse_results.php?
criteria=O:AD:E:4609&page_number=51&template_id=1&sort_
order=1

Official Pablo Picasso Website

http://www.picasso.fr/us/picasso_page_index.php

Picasso's *The Reservoir, Horta de Ebro*

http://smarthistory.org/the-reservoir-horta-de-ebro.html

Create Your Own Picasso–Mr. Picassohead

http://www.mrpicassohead.com/create.html

Art Projects for Kids: How to Draw a Cubist Portrait

http://www.artprojectsforkids.org/2009/02/how-to-draw-cubist-
portrait.html

Interactive 3D Shapes–Prisms

http://www.learner.org/interactives/geometry/3d_prisms.html

National Library of Virtual Manipulatives–Platonic Solids

http://nlvm.usu.edu/en/nav/frames_asid_128_g_3_t_3.html?
open=instructions

JACKSON POLLOCK MAKES A MULTI-COLORED MESS!

• •

JACKSON POLLOCK (1912–1956) was a 20th century American abstract expressionist, born in Cody Wyoming, who best known for his enormous works of art created by splattering, dripping, and pouring paint onto canvas. Pollock's technique was described as *action painting* because he moved around so much and expended so much energy while creating his art. It's no wonder that Pollock's nicknames were *Action Jackson* and *Jack the Dripper*. Pollock's splatter art permeates a sense of "all-overness;" meaning his work lacked a compositional focus. Some might think

Pollock's drips and splatters of paint are chaotic and random, but the artist planned each work carefully. Pollock abandoned titles and, instead, numbered his paintings, to allow observers to see and interpret what they wanted in his works.

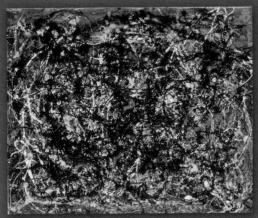

↗ Jackson Pollock, *Number 6* (1949). What do you ogle in this splattered masterpiece?

The Museum of Fine Arts, Houston, TX

fascinating facts

- Pollock used sticks, trowels, or knives, as well as paintbrushes, to create his art.
- Pollock's painting, No. 5 (1948), sold for $140 million in 2006, making it one of the most expensive paintings ever sold.

FAMOUS QUOTES

"When I am painting...I can control the flow of paint: there Is no accident."

"Every good artist paints what he is."

MASTERPIECES TO OGLE
Number 8 (1949)
Number 5 (1948)
Blue Poles (Number 11) (1952)
Lavender Mist (Number 1) (1950)

ART CONCEPTS/SKILLS: abstract expressionism, art appreciation, interpreting art

MATH CONCEPTS/SKILLS: estimation, comparing amounts, fractions, positional language (e.g., top, bottom, middle, left, right, etc.)

WHAT YOU'LL NEED
- large white posterboard (or cardstock)
- tempura paints
- paintbrushes
- paper towels and/or a smock (this might get messy!)

LET'S HAVE FUN!
View, enjoy, and discuss some of Jackson Pollock's works. Do you like his style of art known as action painting? Can you feel the rhythm, movement, and expression Pollock pours into his art? Does his

splatter art seem action-filled to you? Which is your favorite Pollock painting? What would you title it? Why? Tell a story about what you see!

Ogle Jackson Pollock's *Number 6* (1949). What do you see in this work of art? Does this painting make you feel sad or happy? Does it evoke some other feelings? What do you think Pollock was thinking about as he poured his emotions onto the canvas?

Create a Jackson Pollock-like work of art by splattering and dripping various colors of paint onto a large piece of posterboard. You might want to create your action painting outside to prevent any messes. You will find yourself really enjoying splattering! Like Pollock, pour your emotions into the creation of your masterpiece.

View your work and title it. What images do you see in your finished masterpiece? Does your painting evoke feelings of movement? What elements of art do you see in your masterpiece?

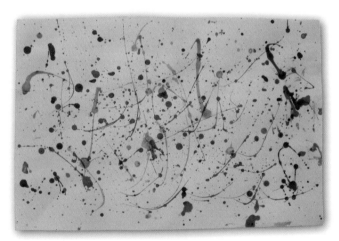

↗ *Dots and Stripes;* Ironically, a boy named Jackson (age 4) created this masterful work of splatter art. How many colors of paint do you ogle?

put oN Your MatH goggLeſ!·························

I doubt Jackson Pollock was thinking about mathematics as he splattered paint onto his canvas. But let's put on our math

goggles and ogle what mathematics might be in his art!

Let's begin by looking for the element of *line* in his works. The lines, some straight, some squiggly and some wiggly create what we see. What other elements of art do you see in his works?

With younger children: Look at all of the colors in your masterpiece. How many colors did you use? What color is used the most? The least? Are there equal amounts of colors used? What color(s) are at the top of the posterboard? The bottom? What colors appear mostly on the left side of your painting? On the right side? In the middle?

With older children: Let's think in terms of fractions. Do you think one-half of your posterboard is covered in paint? Maybe three-fourths? Can you estimate the fractional amounts of each color used?

BOOKS TO OGLE

Jackson Pollock (Getting to Know the World's Greatest Artists Series) by Mike Venezia

Learn about the life of Paul Jackson Pollock in this biography, complete with clever and humorous illustrations and images of the artist's work.

Action Jackson by Jan Greenberg and Sandra Johnson

Older readers will enjoy this biography of Jackson Pollock.

Ish by Peter Reynolds

Discover how beauty is truly in the eye of the beholder! Maybe you could call Pollock's masterpieces art-ish!

Art by Patrick McDonnell

Enjoy learning about Art and the art that Art creates. Art's art featured on the cover of this cleverly humorous book is reminiscent of a Pollock.

More, Fewer, Less by Tana Hoban

Count and compare everyday objects in the photos appearing in wordless book.

WEBSITES TO OGLE (PLEASE VIEW BEFORE SHOWING TO YOUR CHILD
IN CASE CONTENT HAS CHANGED.)

Museum of Modern Art (MoMA)–Modern Kids: Jackson Pollock
 http://www.moma.org/explore/multimedia/audios/1/12
Jackson Pollock Emulator (Just start moving your cursor and watch
the magic!)
 http://www.jacksonpollock.org/

georges seurat's countless dots

GEORGES SEURAT (1859–1891), whose name rhymes with the word "*dot,*" was a 19th century French post-impressionist painter, who revolutionized a painting technique known as pointillism. Instead of mixing yellow and blue to create green, Seurat and other Pointillists would place tiny yellow and blue points side-by-side and slightly overlapping, relying on the viewer's eye to do the mixing. That's the science of this painting technique. Seurat spent a good part of his life studying the science of color and the optical mixing of colors. Sadly, Seurat died from some type of infection at the young age of 31, leaving his last ambitious work, *The Circus* (called *La Parade* in French), unfinished. During his short lifetime, Seurat completed seven major paintings, 40 smaller paintings and sketches, and nearly 500 drawings. However, it was not the quantity of paintings that led to Seurat's fame, but the creation of his magnificent pointillist works.

↖ Georges Seurat, *Young Woman Powdering Herself* (1889). How many dots do you ogle in this pointillist masterpiece?

faScinating factS

- It took Seurat two years to paint his massive *Sunday Afternoon on the Island of La Grand Jatte,* and it contains over two million dots!
- Seurat is considered to be the leader of the Neo-Impressionist movement.

FAMOUS QUOTE

"Some say they see poetry in my paintings; I see only science."

"Originality depends only on the character of the drawing and the vision peculiar to each artist."

MASTERPIECES TO OGLE

Sunday Afternoon on the Island of La Grand Jatte (1884-86)
Le Cirque (1890-1891)
The Side Show (1888)

ART CONCEPTS/SKILLS: pointillism, blending primary colors to create secondary colors

MATH CONCEPTS/SKILLS: estimation, counting, comparing amounts, more than, less than, equal to, fractions, area, measurement

WHAT YOU'LL NEED:

- magnifying lens
- Do•A•Dot™ markers (or oil paints and Q-tips)
- 8.5" X 11" white cardstock

LET'S HAVE FUN!

Sometimes looks can deceive! Using a magnifying glass, view an object (like a coin, bug, or rock) up close. Do you now see features that you did not notice before because everything is now magnified?

View, enjoy, and discuss some of Seurat's works; for example,

Georges Seurat's Countless Dots

Young Woman Powdering Herself or one of his most famous works, *Sunday Afternoon on the Island of La Grande Jatte.* From afar, Seurat's works look like typical paintings, full of color, until you look very closely and you ogle the many, tiny individual points of color that create the many shades of colors. Visit the websites listed below and see up-close views of Seurat's plentiful points.

The Museum of Fine Arts, Houston, TX

↗ Look at all of the colored dots in this pointillist work entitled, *The Bonaventure Pine* (1893) by Paul Signac.

↗ *Somewhere over the Rainbow;* Nina (age 5) correctly captures the colors of the rainbow in her pointillist work. Can you visually estimate how many dots Nina used?

Locate a picturesque setting by either sitting outside or looking out a window. Using Do•A•Dot™ markers (or oil paints and Q-tips), create a Seurat-like piece of artwork by placing many closely spaced multi-colored dots on your white cardstock (or canvas, if you are using oil paints). Like a Pointillist, place two primary colored dots (say red and yellow) side-by-side and overlapping a bit to create a dot of a secondary color (in this

case, orange). View your work and title it. What elements of art do you see in your pointillist masterpiece?

put on your math goggles!

I think Seurat was busy wearing his science goggles as he experimented with color mixing, and so he probably never thought about putting on his math goggles to look for the multitude of mathematics in his artwork! Well, get your math goggles on and ogle the mathematics in your Seurat-inspired masterpiece!

With younger children: Estimate the number of colored dots in your artwork. Now count the dots. How accurate were your estimations? Do you see more of one colored dot than another? What color is used the most? The least? Are there equal amounts of colored dots on your paper? Help your child compute the sum of two or more colored dots.

With older children: Estimate the number of colored dots in your artwork. Now count the dots. How accurate were your estimations?

Explore fractions. View your pointillist masterpiece and try to estimate what fraction of your painting are red dots? Yellow dots?, etc.

Let's keep viewing through our math goggles and explore the mathematical concept of *area*. It has been estimated that the size of a dot in Seurat's painting, S*unday Afternoon on the Island of La Grand Jatte* is $\frac{1}{16}$ of an inch. If the painting measures 6'8" by 10', how many dots are in their entire masterpiece? Tighten up those math goggles and let's figure this out!

In one square inch, there would be 16 X 16 = 256 dots. But how many square inches make up Seurat's *entire* work? If the painting measures 6'8" in length, that translates into 80 inches long (because there are 12 inches in one foot, so there would be 12 X 6 inches = 72 inches in 6 feet, plus the other 8 inches, which equals 80 inches total). Now, the painting is 120 inches tall and that translates into 120 inches (because in 10 feet, there are 12 X 10 inches, which equals 120 inches). Since

Seurat's work is a rectangle, and the area of a rectangle is length times width, then there are 80 inches X 120 inches or 9,600 square inches in his work. If within each individual one square inch there are 256 dots, then there are 256 dots X 9,600 = 2,457,600 dots! That's a multitude of dots!

BOOKS TO OGLE

Georges Seurat (Getting to Know the World's Greatest Artists Series) by Mike Venezia
> Learn about the life of Georges Seurat in this biography, complete with clever and humorous illustrations and images of the artist's work.

Seurat and La Grande Jatte: Connecting the Dots by Robert Burleigh
> Older children can discover the history and technique behind the painting of Seurat's famous masterpiece.

Sunday with Seurat by Julie Merberg and Suzanne Bober
> This mini board book's rhyming text is set against the backdrop of Seurat's many masterpieces.

Katie's Sunday Afternoon by James Mayhew
> See what happens as Katie tries to cool off on a hot day at a local museum by climbing into one of Seurat's famous paintings.

The Dot by Peter Reynolds
> Learn how a teacher's encouragement turns a frustrated and doubtful student into a competent and confident artist.

A Million Dots by Andrew Clements
> Really! This book contains a million dots that you can count–along with interesting number facts.

WEBSITES TO OGLE (PLEASE VIEW BEFORE SHOWING TO YOUR CHILD IN CASE CONTENT HAS CHANGED.)

Close-up of Seurat's *Grande Jatte* and *Circus*
> http://www.webexhibits.org/colorart/jatte.html

Pointillism Practice Page (make your own Pointillist art on your computer screen!)
> http://www.epcomm.com/center/point/point.htm

dinner and dessert with andy warhol

· · · · · · · · · · · · · · · · · · ·

ANDY WARHOL (1928-1987) was a 20th century American pop artist, born in Pittsburgh, Pennsylvania to Czechoslovakian emigrants. He began his career as a commercial illustrator, working for magazines such as *Vogue, The New Yorker,* and *Harper's Bazaar.* Warhol quickly became famous worldwide for his work as a painter, filmmaker, record producer, author, and public figure. In 1945, Warhol enrolled at the Carnegie Institute of Technology (now called Carnegie Mellon University) where he majored in pictorial design. One of Warhol's favorite technique to create art was by photo silk-screening, and some of his most famous works are of Campbell's soup cans, Coca-Cola bottles, and entertainment icons. Although many people would describe Warhol as quite eccentric (for example, he owned twenty-five cats all named Sam!), he still remains as one of the most influential artists of the 20th century.

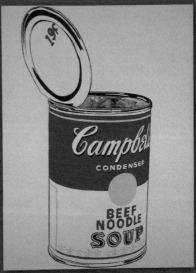

↗ Andy Warhol, *Big Campbell's Soup Can 19¢* (1962). Ogle the color, line, shape, and form in Warhol's work of art.

fascinating facts

- The Andy Warhol Museum is located in his hometown of Pittsburgh, Pennsylvania.
- The media often referred to Andy Warhol as the "Prince of Pop."

FAMOUS QUOTES

"Everyone will be famous for 15 minutes."

"Pop art is for everyone."

MASTERPIECES TO OGLE

Campbell's Soup I (1968)
Ice Cream Dessert (1959)
10 Marilyns (1967)
Green Coca Cola Bottles (1962)

ART CONCEPTS/SKILLS: pop art, form, color, value

MATH CONCEPTS/SKILLS: three-dimensional shapes, cones, cylinders, spheres

WHAT YOU'LL NEED

- 8.5" X 11" white paper (cut to measure 5" X 11")
- brown construction paper
- Campbell's soup label
- net of a cone (see website below)
- jumbo 2" colored pompoms (see website below)
- tape

LET'S HAVE FUN!

View, enjoy, and discuss some of Andy Warhol's works. When you ogle Warhol's *Big Campbell's Soup Can 19¢,* is it easy to understand why Warhol was labeled a pop artist? What do you like about his

works? Do you like his colorful silkscreen works?

Ogle Warhol's *Ice Cream Dessert.* What flavors of ice cream do you think are pictured? What elements of art do you see in this work?

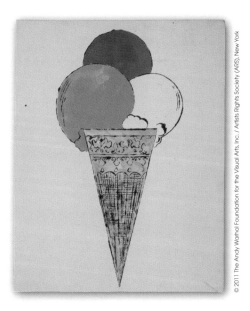

🢔 Andy Warhol, *Untitled (Ice Cream Dessert),* c. 1959. When you ogle this work, it might make you hungry. Put on your math goggles and ogle the spherical scoops of ice cream situated on top of their conical container!

 put oN Your Math gogglef! ······················

View *Campbell's Soup I* and *Ice Cream Dessert* series. What type of shape is the can of soup? What shape are the scoops of ice cream and the ice cream cone?

The soup can is an example of a *cylinder.* In mathematics, we define a cylinder as a solid (meaning a three-dimensional shape) comprised of a curved surface and two congruent (meaning equal in size and shape) circular bases. Although the ice cream cone in Warhol's work might look like a triangle, in mathematics, a *cone* is not a flat, two-dimensional shape, but a three-dimensional shape. A cone is similar to a cylinder, but it only has one circular base, and its curved surface comes to a point (or what we call in mathematics, a vertex).

How about the scoops of ice cream? What mathematical term is used to describe them? These colorful scoops are called spheres, which might be described as a solid that is perfectly round.

With your math goggles on, look for examples of cylinders, cones, and spheres around you. You will ogle a multitude of them! Examples of cylinders you might spy include cans of food or soda, a candle, a pencil, a straw, a cork, etc. Cones are a little harder to find, but might include a witch's hat, a water dispenser cup, the turret on a castle, a cheerleader's horn, etc. Spheres are everywhere: for example, a ball, an orange, a blueberry, a globe, a gumball, the top of a light bulb, etc.

With younger children: Peel a label off of a Campbell's soup can and tape it in the middle of a piece of 5" X 11" white paper placed landscape style (meaning it is oriented such that it is longer than it is taller). If you look at this strip of paper, clearly, it is in the shape of a rectangle, a two-dimensional shape (meaning it has a length and a width). So, how can you turn this rectangle into a cylinder, as we want a soup can! After some experimentation, help your child see that by curving the paper and making the shorter ends of the paper meet at a seam, this will result in a cylinder. Place tape along the seam and enjoy your Warhol tomato soup can masterpiece! View your soup can and title it. What other elements of art do you see in your work of pop art?

In math, a "net" of a three-dimensional shape is the outline of the shape if you could open it up and flatten it out. Think of the cylinder we just created out of a rectangle. The rectangular piece of white paper is the net of a cylinder. What do you think the net of a cone might look like if we were able to flatten out a cone?

Trace a net of a cone (see website below) onto a piece of brown construction paper. Encourage your child to transform this flat, triangular-ish shape into a three-dimensional cone. Hint: Roll the paper, like you did when creating the soup can from the rectangular strip of white paper. After forming the cone, tape the seam to secure its form.

Place three pompoms of different colors into the cone (no need to glue them!). Ta da! You now have your very own Warhol-inspired ice cream dessert masterpiece! View your work and title it. What other elements of art do you see in this piece of pop art?

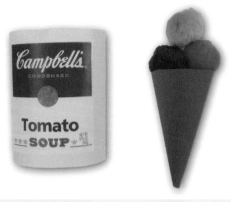

↗ *Time for Dinner* (Finn, age 4) and *Time for Dessert* (Finn, age 4). Who would have ever thought that food was so mathematical!

With older children: Create a Warhol-like tomato soup can and an ice cream cone in the same fashion as described above.

Let your child hold and examine a real-life example of a cube (like a die) or a rectangular prism (say a cereal or shoe box). Challenge your child to make a net of the three-dimensional shape; that is, make a sketch of what this solid might look like when flattened. To check your guess, roll up/fold your net and see if it makes the solid you want!

BOOKS TO OGLE

Andy Warhol (Getting to Know the World's Greatest Artists Series) by Mike Venezia

Learn about the life of Andy Warhol in this biography, complete with clever and humorous illustrations and images of the artist's work.

Cubes, Cones, Cylinders, & Spheres by Tana Hoban

Discover and enjoy photographs of these 3D shapes abounding

in your world in this wordless book.

Mummy Math: An Adventure in Geometry by Cindy Neuschwander
Two boys escape from an ancient pyramid by using clues about 3D shapes.

I Spy Shapes in Art by Lucy Micklethwait
You won't believe how many 2D and 3D shapes you will find!

WEBSITES TO OGLE (PLEASE VIEW BEFORE SHOWING TO YOUR CHILD IN CASE CONTENT HAS CHANGED.)

Andy Warhol Foundation
http://www.warholfoundation.org/

Andy Warhol's Marilyn Prints–You Choose the Colors
www.webexhibits.org/colorart/marilyns.html

Andy Warhol Silkscreen Printing–Create Your Own!
www.warhol.org/interactive/silkscreen/main.html

National Library of Virtual Manipulatives–View, spin, and count faces on solids
http://nlvm.usu.edu/en/nav/frames_asid_128_g_1_t_3.html?open=instructions&from=topic_t_3.html

Net of a Cone
http://www.korthalsaltes.com/model.php?name_en=cone

Jumbo 2-inch Colored Pom Poms
http://www.discountschoolsupply.com/Product/ProductDetail.aspx?product=24329&keyword=jumbo%20colored%20pompoms&scategoryid=0

Art Glossary

• • • • • • • • • • • • • •

Abstract art: 20th century art movement where artists depict people, things, or scenes not as they appear to our eyes, but altered, using shapes and colors, which represent the artists' emotions. Famous abstract artists include Josef Albers, Sonia Delaunay, Wassily Kandinsky, Paul Klee, and Piet Mondrian.

Abstract expressionism: art movement that began in America in the mid 1940's, whereby artists quickly and forcefully apply dramatic colors to very large canvasses in order to express their feelings and emotions. Famous abstract expressionists include Richard Diebenkorn, Willem de Kooning, Jackson Pollock, and Mark Rothko.

Automatic drawing: drawing technique whereby an artist randomly (by chance) and unconsciously (without thinking) moves a pen across a paper. Used by Andre Masson, Hans Arp, and Joan Miró.

Color: one of the seven elements of art; produced when light strikes an object and is reflected back to the eye.

Complementary colors: colors that are directly opposite each other on the color wheel; for example, red and green, blue and orange, and violet and yellow. When mixed, complementary colors form brown or gray.

Cubism: art movement that began in the early 1900s whereby artists painted the subjects in their works from many angles and viewpoints. Famous Cubists include Georges Braque, Juan Gris, and Pablo Picasso.

Elements of art: the seven fundamental components used by an artist when creating art. The seven elements of art are: color, form, line, shape, space, and value.

Dada: cultural, anti-war movement that began in Switzerland around 1916 that rebelled against conventional art techniques and celebrated the irrational and absurd. Dadaists include Hans Arp, Marcel Duchamp, and Max Ernst.

Expressionism: a movement that flourished, especially in Germany, at the beginning of the 20th century whereby artists expressed their emotions, rather than objective observation (what they actually ogled), through emphasis, distortion, and exaggeration. Famous expressionists include Max Beckmann, Ernst Ludwig Kirchner, and Edvard Munch.

Fauvism: short-lived art movement that began in the early 1900s that so shocked the public that Fauvists were called "wild beasts" or "fauves" (in French). Fauve artwork is characterized by bold brushstrokes and the use of intensely vivid colors to express extreme emotion rather than represent the subject being painted. Famous Fauvists include Andre Derain, Henri Matisse, and Georges Rouault.

Folk art: art that is handed down through many generations, made by people from a particular region, and which depicts the everyday life and times they share. Famous folk artists include Clementine Hunter and Grandma Moses.

Form: one of the seven elements of art; refers to three-dimensional shapes such as cubes, cones, cylinders, spheres, prisms, etc.

Gouache: painting technique in which heavy, opaque watercolor paint, mixed with gum, is used to produce a stronger color. Pronounced as "gwash," it comes from the Italian word, *aguazzo,* for "mud." Artists who used this technique included Albrecht Durer, George Rouault, and Henri Matisse.

Impressionism: style of painting that began in Paris, France in the mid 1800s characterized by short brushstrokes, creating a blurred effect up-close but, not from afar. Famous Impressionist painters include Mary Cassatt, Edgar Degas, Edouard Manet, Claude Monet, Berthe Morisot, Camille Pissarro, and Pierre Auguste Renoir.

Line: one of the seven elements of art; refers to the continuous mark made by a moving point. A line can be straight, wavy, dotted,

dashed, thick, or thin. It can define a space or create a pattern, outline, or movement.

Minimalism: style of art, also called ABC art, popular in the 1960s, characterized by a minimum number of colors, values, shapes, lines, and textures. Minimalists paint with simplicity and without any personal emotion. Famous Minimalists include Ellsworth Kelly, Donald Judd, Agnes Martin, and Robert Morris.

Optical (or Op) art: 1960's art movement in which artists create movement through the use of lines and patterns of lines. Famous Op artists include Bridget Riley and Victor Vasarely.

Pointillism: painting technique in which tiny dots of primary colors are used to generate secondary colors. Up (very) close, the dots are discernible (you can ogle them) but, from a distance, the colored dots blend together. Famous pointillists include Henri-Edmond Cross, Georges Seurat, and Paul Signac.

Pop art: art movement that began in England in the mid 1950s whose name referred to the "popular" images artists captured from the mass media, advertising, entertainment, and from consumer products. Pop artists often used mechanical means of reproduction, such as silk-screening. Famous Pop artists include Jasper Johns, Roy Lichtenstein, Robert Rauschenburg, and Andy Warhol.

Post-Impressionism: art period following Impressionism at the end of the 1800s whereby artists used thick applications of vivid colors and distinctive brushstrokes, but added more emotion to their works by emphasizing geometric forms. Famous Post-Impressionists include Paul Cezanne, Paul Gauguin, Henri Rousseau, Georges Seurat, Henri de Toulouse-Lautrec, and Vincent van Gogh.

Primary colors: the colors red, yellow, and blue from which all of the other colors can be created.

Secondary colors: the colors obtained by mixing equal amounts of two primary colors; for example, orange (red + yellow), green (blue + yellow), and violet (red + blue) .

Shape: one of the seven elements of art; refers to an object having the two dimensions of length and width.

Space: one of the seven elements of art; refers to the area or distance above or below, in front or behind, or between or within objects.

Surrealism: cultural movement that began in the late 1920s whereby artists painted mostly from their dreams or from thoughts that popped into their heads, rendering their work seemingly nonsensical and difficult to interpret. Famous surrealist artists include Salvador Dali, Max Ernst (also a Dadaist), Rene Magritte, and Joan Miró.

Texture: one of the seven elements of art; refers to the surface of an object as being smooth, rough, etc.

Value: one of the seven elements of art; refers to the lightness or darkness of a color.

even More children's Literature to ogle featuring Art

• •

Listed and categorized below are some of my favorite children's books, not mentioned earlier, that feature artists or famous works of art.

Math-Related Art Books

Counting with Wayne Thiebaud by Susan Goldman Rubin
I Spy Shapes in Art by Lucy Micklethwait
I Spy Two Eyes: Numbers in Art by Lucy Micklethwait
Museum Shapes by The Metropolitan Museum of Art
Museum 1 2 3 by The Metropolitan Museum of Art
Math-terpieces: The Art of Problem-Solving by Greg Tang
Lines by Philip Yenawine
Shapes by Philip Yenawine

Biographies of Famous Artists

Adventures in Art Series (various authors)
Artists in Their Time Series (various authors)
Delicious: The Life & Art of Wayne Thiebaud by Susan Goldman Rubin
Famous Artists Series (various authors)
Getting to Know the World's Greatest Artists Series by Mike Venezia
History of Women Artists for Children by Vivian Sheldon Epstein
The Life and Work of…Series (various authors)
Lives of the Great Artists by Charlie Ayres
Lives of the Artists: Masterpieces, Messes (and What the Neighbors Thought)
 by Kathleen Krull
MoMA Artist Series by Carolyn Lancher
Smart about Art Series (various authors)
Vincent's Colors by The Metropolitan Museum of Art *Who Was…Series* by True Kelley
13 Artists Children Should Know by Angel Wenzel
13 Women Artists Children Should Know by Bettina Schuelmann
50 American Artists You Should Know by Debra N. Mancoff
50 Artists You Should Know by Thomas Koster
50 Women Artists You Should Know by Christiane Weidemann
50 Paintings You Should Know by Kristina Lowis
100 Artists Who Shaped the World by Barbara Krystal

Stories Featuring Artists or Art

Anna's Art Adventure by Bjorn Sortland
Art by Patrick McDonnell
Art Dog by Thacher Hurd
Art from Her Heart: Folk Artist Clementine Hunter by Kathy Whitehead
Harold and the Purple Crayon by Crockett Johnson
I Love You the Purplest by Barbara M. Joosse
Ish by Peter H. Reynolds
Klimt and His Cat by Berenice Capatti

Seen Art? by Jon Scieszka
Seurat and La Grande Jatte by Robert Burleigh
The Dot by Peter H. Reynolds
The Great Migration: Paintings by Jacob Lawrence by MOMA
The Sound of Colors by Jimmy Liao
Books by Laurence Anholt
Books by James Mayhew

Picture Books Containing Works of Art
A is for Art: An Abstract Alphabet by Stephen Johnson
Alphab'art by Anne Guery and Olivier Dussutour
An American Collection: Works from the Amon Carter Museum by Patricia Junker
Can You... Series by The Metropolitan Museum of Art
Children's Book of Art by DK Publishing
Colors of the Museum of Fine Arts, Houston by Caroline Desnoettes
Colors by Philip Yenawine
Come Look with Me (Series) by Gladys Blizzard
Do You See What I See?: The Art of Illusion by Angela Wenzel
Guggenheim Museum Collection: A to Z edited by Nancy Spector
Kimbell Art Museum: Handbook of the Collection by Timothy Potts
Look! Zoom in on Art by Gillian Wolfe
Master Paintings in The Art Institute of Chicago by James N. Wood
Masterpieces of The Metropolitan Museum of Art by The Metropolitan Museum of Art
Modern Art Museum of Fort Worth by Michael Auping and Andrea Karnes
National Gallery of Art: Washington by John Walker
The ABCs of Art by Julie Aigner-Clark
The Museum of Modern Art New York by Sam Hunter
Tidying Up Art by Ursus Wehrli
Women Artists: The National Museum of Women in the Arts by Susan Fisher Sterling
Board books by Julie Appel and Amy Guglielmo
Board books by Julie Merberg and Suzanne Bober
Book by Claire d'Harcourt
Books by Lucy Micklethwait
Books by Bob Raczka

Coloring Books
Art Masterpieces to Color: 60 Great Paintings from Botticelli to Picasso by Marty Noble
Color Your Own...Paintings by Muncie Hendler
Color Your Own...Paintings by Marty Noble
Masterpieces: A Fact-Filled Coloring Book by Mary Martin
The M.C. Escher Coloring Book by Harry N. Abrams, Inc.
Coloring books by Prestel Publishing

Sticker Books
Sticker Art Shapes (Series) by Sylvie Delpech and Caroline Leclerc

Art Activity Books and Resources
Around the World Art & Activities by Judy Press
Art Activity Packs by Mila Boutan
Art Explorers (Series) by Joyce Raimondo
Art Really Teaches by Ruth Velasquez
Discovering Great Artists by MaryAnn F. Kohl and Kim Solga
Hand Print Animal Art by Carolyn Carreiro
How to Talk to Children about Art by Francoise Barbe-Gall
How to Teach Children Art by Evan-Moor
Masterpiece of the Month by Jennifer Thomas
The Art Book for Children by Phaidon
Books by Rosie Dickins

even More Websites to ogle featuring Art!

Ogle these websites if you haven't had enough fun yet exploring art!

Art Express
A variety of art activities for students in grades 1-5
http://www.harcourtschool.com/menus/art_express.html

Art Junction
Educational website containing art activities, projects, and resources
http://www.artjunction.org/

Art Sonia
Online museum of children's artwork
http://www.artsonia.com/museum/

Artcyclopedia
Clearing house of art information searchable by artist name, title of work, or museum
http://www.artcyclopedia.com/

Artist's Tool Kit
Explore the visual elements and principles of art
http://www.artsconnected.org/toolkit/explore.cfm

ArtLex – Art Dictionary
Art dictionary plus a collection of images, quotes, and more
http://www.artlex.com/

ARTSEDGE
Free digital resource of arts materials sponsored by the Kennedy Center
http://artsedge.kennedy-center.org

AskArt – Artists' Directory
Search for an artist and discover biographical facts, current exhibits, images of the artist's work, etc.
http://www.askart.com/AskART/a.aspx

Crayola
Coloring pages, craft ideas, activities, and more
http://www.crayola.com/

Enchanted Learning – Art Activities and Projects for Students
Art activities and projects for children ages 4-10
http://www.enchantedlearning.com/artists/projects.shtml

Fact Monster – Biographies of Famous Artists
Learn about the life and work of 75 famous artists
http://www.factmonster.com/ipka/A0882839.html

Harcourt Art Express
Art activities for children in grades 1-5
http://www.harcourtschool.com/menus/art_express.html

Haring Kids
Artist Keith Haring's selection of games, puzzles, stories, lessons, pictures to color, and more
http://www.haringkids.com/

Incredible Art Lessons
Educational website containing art ideas and activities
http://www.princetonol.com/groups/iad/lessons/middle/for-kids.htm

KinderArt.com
Collection of free art lessons
http://www.kinderart.com/index.html

A Lifetime of Color
Variety of art-based interactive games
http://www.alifetimeofcolor.com/main.taf?p=4

The Metropolitan Museum of Art – Explore & Learn
Just like the title suggests…explore and learn about art!
http://www.metmuseum.org/explore/index.asp

MixPix!
Interactive site that takes famous masterpieces, cuts them into sixteen pieces, and challenges the user to reassemble
http://www.epcomm.com/center/mixpix/mixpix.htm

National Gallery of Art – NGA Kids' Page
Collection of art activities and projects
http://www.nga.gov/kids/kids.htm

Palette Knife Painting
Paint like van Gogh using this interactive site
http://www.epcomm.com/center/vangogh/vangogh.htm

999 Coloring Pages
Enjoy coloring famous works of art
http://other.999coloringpages.com/Coloring+Pages/Famous+Paintings.htm

smART Kids – Education Resources
Art exploration activities developed by the Smart Museum of Art, University of Chicago
http://smartmuseum.uchicago.edu/smartkids/home.html

Smithsonian American Art Museum – Education Resources
Content links, teacher guides, and student activities
http://www.americanart.si.edu/education/resources/

WebMuseum, Paris
Artist index and art glossary
http://www.ibiblio.org/wm/paint/

Art credits

• • • • • • • • • • •

The author enthusiastically expresses her deepest gratitude to the museums, organizations, estates, and individuals that contributed images adorning this book.

 Josef Albers, *Homage to the Square: Apparition*, 1959, oil on Masonite, 47½ x 47½ in. (120.6 x 120.6 cm). Solomon R. Guggenheim Museum, New York, 61.1590. © 2011 The Josef and Anni Albers Foundation / Artists Rights Society (ARS), New York

 Josef Albers, *Homage to the Square: "Gentle Hour"*, 1962, oil, acrylic on board, 48⅛ X 48⅛ in. Collection of Walker Art Center, Minneapolis; Gift of T.B. Walker Foundation, 1967. © 2011 The Josef and Anni Albers Foundation / Artists Rights Society (ARS), New York

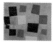 Jean (Hans) Arp © ARS, NY, *Squares Arranged According to the Laws of Chance*, 1917, cut-and-pasted papers, ink, and bronze paint, 13⅛ X 10¼ in. Gift of Philip Johnson. (496.1970). The Museum of Modern Art, New York, NY, U.S.A. Digital Image © The Museum of Modern Art/ Licensed by SCALA/Art Resource, NY. © 2011 Artists Rights Society (ARS), New York / VG Bild-Kunst, Bonn

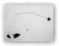 Alexander Calder, *Untitled*, circa 1938, metal, wood, wire and string, 1500 x 2000 x 2000 mm. Lent by Mary Trevelyan 1992. © 2011 Calder Foundation, New York / Artists Rights Society (ARS), New York. Photo credit: Tate, London 2009

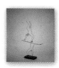 Alexander Calder, *Two Acrobats*, 1929, painted wire and wood base, 34⁹/₁₆ x 21⅝ x 6½ in. (87.8 x 55 x 16.5 cm). The Menil Collection, Houston. © 2011 Calder Foundation, New York / Artists Rights Society (ARS), New York. Photo credit: Hester + Hardaway Photographers Fayetteville Texas

 Salvador Dali © ARS, NY, *The Persistence of Memory*, 1931, oil on canvas, 9½ X 13 in. Given anonymously. The Museum of Modern Art, New York, NY, U.S.A. Digital Image © The Museum of Modern Art/Licensed by SCALA/Art Resource, NY. © Salvador Dalí, Fundació Gala-Salvador Dalí, Artists Rights Society (ARS), New York, 2011

 Richard Diebenkorn, *Berkeley #19*, 1954, oil on canvas, 59½ x 57 in. Collection of The University of Arizona Museum of Art & Archive of Visual Arts, Tucson; Gift of Gloria Vanderbilt, American Federation of Arts, Acc. No. 1962.016.001

 Clementine Hunter, *Call to Church and Flowers*, 1970, oil on canvas, 36 x 48 in. National Museum of Women in the Arts, Washington, D.C.; Gift of Dr. Robert F. Ryan. © The Cane River Art Corporation

 Robert Indiana © ARS, NY, *Love*, Indiana Stable May 66, 1966, silkscreen, 32 X 24 in. Gift of Posters Original, Limited, The Museum of Modern Art, New York, NY, U.S.A. Digital Image © The Museum of Modern Art/Licensed by SCALA/Art Resource, NY. © 2011 Morgan Art Foundation / Artists Rights Society (ARS), New York

 Jasper Johns, *Cicada*, 1979, oil on canvas, 48 X 36 in. (121.9 X 91.4 cm). The Museum of Fine Arts, Houston; Museum purchase with funds provided by the Caroline Wiess Law

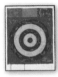

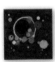
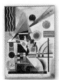

Henri Matisse, *Woman in a Purple Coat*, 1937, oil on canvas, 31⅞ X 25¹¹/₁₆ in. (81 X 65.2 cm), frame: 41¼ X 35½ X 4¾ in. (104.8 X 90.2 X 12.1 cm). The Museum of Fine Arts, Houston; Gift of Audrey Jones Beck. © 2011 Succession H. Matisse / Artists Rights Society (ARS), New York

Maria Sibylla Merian, *Plate 9* (from *"Dissertation in Insect Generation and Metamorphosis in Surinam,"* second edition), 1719, hand-colored engraving on paper, 12¾ x 9¾ in. National Museum of Women in the Arts, Washington, D.C.; Gift of Wallace and Wilhelmina Holladay

Joan Miró © ARS, NY, *Constellation: Awakening in the Early Morning*, 1941, gouache and oil wash on paper, 18⅛ X 15 in. (46.0 X 38.0 cm). APg 1993.05. Acquired with the generous assistance of a grant from Mr. and Mrs. Perry R. Bass. Kimbell Art Museum, Fort Worth, TX, U.S.A. Photo Credit: Kimbell Art Museum, Fort Worth, Texas / Art Resource, NY. © 2011 Successió Miró / Artists Rights Society (ARS), New York / ADAGP, Paris

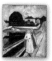

Edvard Munch © ARS, NY, *Girls on the Pier*, c. 1904, oil on canvas, 31¾ X 27¼ in. (80.5 X 69.3 cm). AP 1966.06. Kimbell Art Museum, Fort Worth, TX, U.S.A. Photo Credit: Kimbell Art Museum, Fort Worth, Texas/Art Resource, NY. © 2011 The Munch Museum / The Munch-Ellingsen Group / Artists Rights Society (ARS), NY

Georgia O'Keeffe © ARS, NY, *An Orchid*, 1941, pastel on board, 21¾ X 27⅝ in. Bequest of Georgia O'Keeffe. © The Museum of Modern Art, New York. (556.1990) The Museum of Modern Art, New York, NY, U.S.A. Digital Image © The Museum of Modern Art/Licensed by SCALA/ Art Resource, NY. © 2011 Georgia O'Keeffe Museum / Artists Rights Society (ARS), New York

Georgia O'Keeffe, *Red Hill and White Shell*, 1938, oil on canvas, 30 X 36½ in. (76.2 X 92.7 cm), frame: 31½ X 37⅜ x 1¾ in. (80 X 94.9 X 4.4 cm). The Museum of Fine Arts, Houston: Gift of Isabel B. Wilson in memory of her mother, Alice Pratt Brown. Additional copyright holder: Artists Rights Society, New York. © 2011 Georgia O'Keeffe Museum / Artists Rights Society (ARS), New York

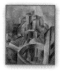

Pablo Picasso © ARS, NY, *The Reservoir, Horta de Ebro, Horta de Ebro*, summer 1909, oil on canvas, 24⅛ X 20⅛ in. Fractional gift of a private collector to The Museum of Modern Art, New York. (81.1991). The Museum of Modern Art, New York, NY, U.S.A. Digital Image © The Museum of Modern Art/Licensed by SCALA/Art Resource, NY. © 2011 Estate of Pablo Picasso / Artists Rights Society (ARS), New York

Jackson Pollock, *Number 6*, 1949, duco and aluminum paint on canvas, 44³/₁₆ X 54 in. (112.3 X 137.2 cm), frame: 51 X 60¾ X 2½ in. (129.5 X 154.3 X 6.4 cm). The Museum of Fine Arts, Houston; Gift of D. and J. de Menil. © 2011 Pollock-Krasner Foundation / Artists Rights Society (ARS), New York

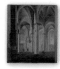

Pieter Jansz Saenredam, *Interior of the Buurkerk, Utrecht*, 1645, oil on panel, 22⅞ x 20 in. (58.1 x 50.8 cm). AP 1986.09. Kimbell Art Museum, Fort Worth, Texas

Georges Seurat, *Young Woman Powdering Herself*, 1889, oil on wood, 9¾ X 6⁵/₁₆ in. (24.8 X 16 cm), frame: 17⅝ X 14¼ X 3 in. (44.8 X 36.2 X 7.6 cm). The Museum of Fine Arts, Houston; Gift of Audrey Jones Beck

Paul Signac, *The Bonaventure Pine*, 1893, oil on canvas, 25⅞ X 31⅞ in. (65.7 X 81 cm). The Museum of Fine Arts, Houston; Gift of Audrey Jones Beck. © 2011 Artists Rights Society (ARS), New York

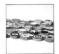
Wayne Thiebaud © Copyright, Yo-Yos, 1963, oil on canvas, support: 24 X 24 inches (60.96 X 60.96 cm). Gift of Seymour H. Knox, Jr., 1963. Albright-Knox Art Gallery, Buffalo, New York, New York State, U.S.A. Photo Credit: Albright-Knox Art Gallery/Art Resource, NY

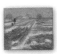
Vincent van Gogh, Landscape with Snow (Paysage enneigé), late February 1888, oil on canvas, 15¹/₁₆ x 18³/₁₆ in. (38.2 x 46.2 cm). Solomon R. Guggenheim Museum, New York, Thannhauser Collection, Gift, Hilde Thannhauser, 1984, 84.3239

Andy Warhol, Big Campbell's Soup Can, 19¢, 1962, acrylic and graphite on canvas, 72 x 54½ in. (182.9 x 138.4 cm). The Menil Collection, Houston. Photo Credit: Hester + Hardaway Photographers Fayetteville Texas. © 2011 The Andy Warhol Foundation for the Visual Arts, Inc. / Artists Rights Society (ARS), New York

Andy Warhol © Copyright, Untitled (Ice Cream Dessert), c. 1959, ink and ink wash on Strathmore paper, 28⁵/₈ X 22⁵/₈ in. Photo Credit: The Andy Warhol Foundation, Inc./ Art Resource, NY. © 2011 The Andy Warhol Foundation for the Visual Arts, Inc. / Artists Rights Society (ARS), New York

closing thoughts

• • • • • • • • • • • • • • • • • • •

" The mathematician's patterns, like the painter's or poet's, must be beautiful. The ideas, like the colours or the words, must fit together in a harmonious way. Beauty is the first test: There is no permanent place in the world for ugly mathematics. "

– G. H. HARDY, 20TH CENTURY ENGLISH MATHEMATICIAN

" Never take off your math goggles! "

– ROBIN A. WARD, 21ST CENTURY MATHEMATICS EDUCATOR

credits

• • • • • • • •

Michael Clements, photographer
Photo cover

Sienna DelConte
Artists sketches

Notes

Notes

Notes

Notes

Notes